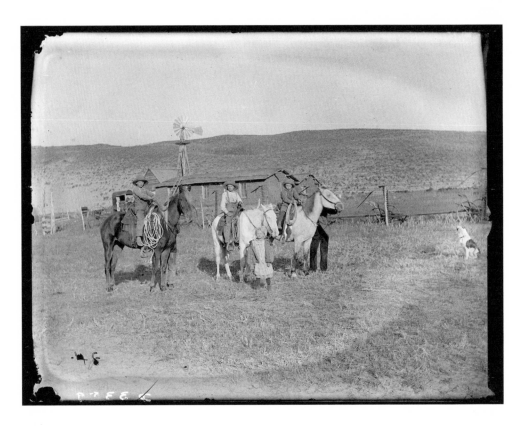

The William Erickson
children, ready to ride.
(NSHS ID: 14394.)

NANCY PLAIN

Light on the Prairie

Solomon D. Butcher,
Photographer of Nebraska's
Pioneer Days

UNIVERSITY OF NEBRASKA PRESS • LINCOLN & LONDON

⊗

Publication of this volume was assisted by a grant from the Friends
of the University of Nebraska Press in memory of Frederick M. Link,
founding president of Friends.

Library of Congress Cataloging-in-Publication Data
Plain, Nancy.
Light on the prairie : Solomon D. Butcher, photographer of Nebraska's
pioneer days / Nancy Plain.
 p. cm.
Includes bibliographical references.
ISBN 978-0-8032-3520-5 (pbk. : alk. paper)
1. Butcher, Solomon D. (Solomon Devore), 1856–1927—Juvenile
literature. 2. Photographers—Nebraska—Biography—Juvenile
literature. 3. Nebraska—History—Juvenile literature. I. Title.
TR140.B88P53 2012
770.92—dc23
[B]
2012001341

Set in Galliard.

For my mother, Belva Plain, my inspiration in everything

We come and go, but the land is always here. And the people who love it and understand it are the people who own it—for a little while.—WILLA CATHER, *O Pioneers!*

Contents

Acknowledgments

Biographical information about Solomon Butcher is from *Pioneer History of Custer County, and Short Sketches of Early Days in Nebraska*, by Solomon D. Butcher; and from *Solomon D. Butcher: Photographing the American Dream*, by John E. Carter.

I am deeply grateful to John E. Carter and Linda Hein, of the Nebraska State Historical Society, for all their generous help and for sharing with me so many wonderful stories of old Nebraska.

A Note on Terminology

The terms Native American, American Indian, and Indian are
used interchangeably throughout this book to denote the Na-
tive people who lived in North America for thousands of years
before the Europeans arrived.

Light on the Prairie

Introduction

A Tenderfoot Goes West

In the springtime of 1880, two white-topped wagons traveled, creaking and swaying, across the Nebraska prairie. "Prairie schooners," the wagons were called. They were like boats on a rolling sea—a sea made of earth and waves of grass. Solomon Devoe Butcher and his father, brother, and brother-in-law had left their old home in Illinois and were heading west. They were pioneers, looking to start a new life as farmers on the frontier, and they would fetch the rest of the family as soon as they got settled. Their journey had been long and rough. Especially for Solomon, who called himself a "tenderfoot."[1] He was twenty-four years old but had never slept out under the stars before, and he claimed not to have done a hard day's work in the past twelve years.

After seven weeks and seven hundred miles, the Butcher party

reached its destination—Custer County, Nebraska. The men were now in the center of the state, which is itself in the center of the country, in the vast and beautiful region called the Great Plains. The plains run north from Texas all the way into southern Canada, and they stretch westward from the Missouri River, rising gradually until they meet the Rocky Mountains. Where the Butchers stopped their wagons there was only one small farmhouse, like an island on the land. All around it, as far as they could see, was just sky and pure prairie. Not a tree or a bush in sight, and the only sound was the *whooosh* of wind in the grass.

Solomon and his family were part of the great migration of settlers who came to the Great Plains after the Civil War—between 1865 and 1890, more than one million to Nebraska alone. Most came because the U.S. government was giving away land. In 1862 President Abraham Lincoln had signed the Homestead Act, which provided 160 acres of free land for anyone with the will to live on it and farm it—to "prove it up"—for five years. Men and women at least twenty-one years old, citizens and even citizens-to-be, were eligible, and there were millions of acres available on the plains.

A far-flung mix of people came to try their luck. They sailed by steamship from Europe. They came from all over America. Civil War veterans claimed land, and so did African Americans, recently freed from slavery. Many of these emigrants arrived with only a couple of dollars in their pockets. They had never owned much of anything before, let alone 160 acres of farmland. On the plains, they would face an extreme climate and many other hardships in their struggle to make a new life. Yet Solomon Butcher echoed the thoughts of thousands of newcomers when he wrote, "I considered this the finest country I had seen since leaving the East, for a poor man seeking a home."[2]

Solomon and his father each claimed land in Custer County.

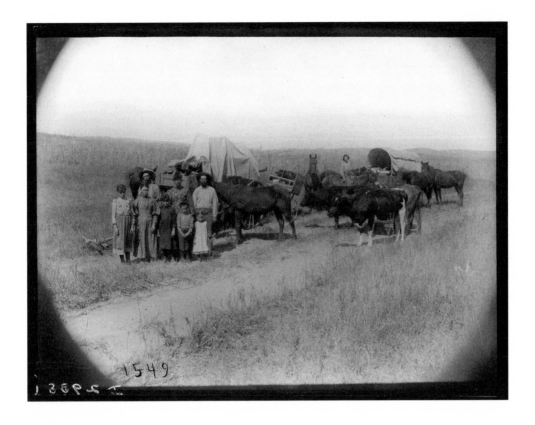

1549

Then they set about building a house. Because timber was scarce, they did what others on the prairie were doing: they made a house out of the earth itself, plowing up strips of sod and laying them like bricks to form the walls and roof. After their sod house, or "soddy," was finished came the work of planting corn—breaking more tough sod and tramping up and down the field under the prairie sun.

It did not take long for Solomon to realize that the farmer's life was not for him. As a teenager back in Illinois, he had learned the art of photography and had been drawn to it ever since. He established the first photography studio in his county, and soon he was mixing farmwork with photography, dashing off to take pictures of other settlers. In 1886 he had his eureka moment, the biggest

Immigrants arriving in Custer County.
(NSHS ID: 12377.)

3

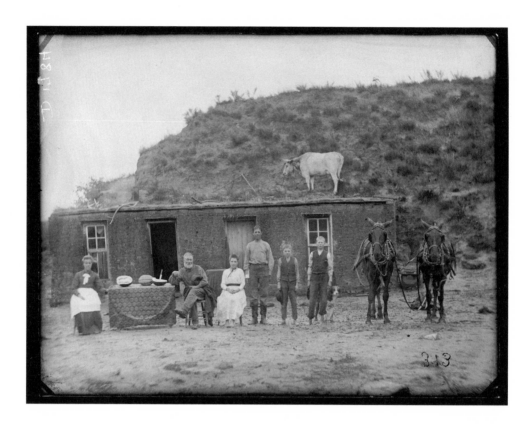

idea of his life. He would compile a book, a photographic history of the pioneers of Custer County. Along with pictures, he would include in the book his neighbors' biographies and recollections. He called the plan his "history scheme," and from the moment he had the idea, he wrote, "I was so elated that I lost all desire for rest . . ."[3]

With his camera and portable darkroom stowed in the back of a horse-drawn wagon, Solomon began to roam. In the clear prairie light, he posed the people of Custer County with the things that were important to them. In his photographs, farm families stand in their fields or in front of their soddies, flanked by their household possessions, their horses, and usually a dog or two. Ranchers are pictured on horseback with their cattle or

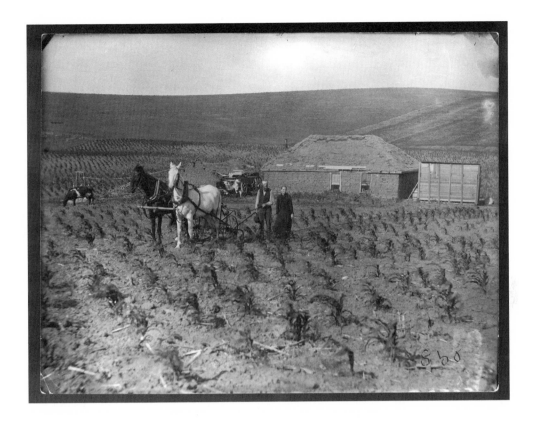

flocks of sheep. Butcher's lens focused on cowboys and cowgirls, schoolteachers and storekeepers. He loved to photograph children, whether milking cows, eating watermelon, or clutching their favorite toys. His subjects were everyone and everything that was part of life on the plains. And always, behind Solomon's people is the wide land itself, reaching far into the distance.

Some of his friends thought that he was wasting his time. Others thought he was just lazy and waited for him to face up to the real work of farming. "Some called me a fool, others a crank, but I was too much interested in my work to pay any attention to such people," he wrote.[4] He continued to crisscross the prairie for years, taking pictures and gathering stories. He saw the wild

A cornfield on the prairie.
(NSHS ID: 10343.)

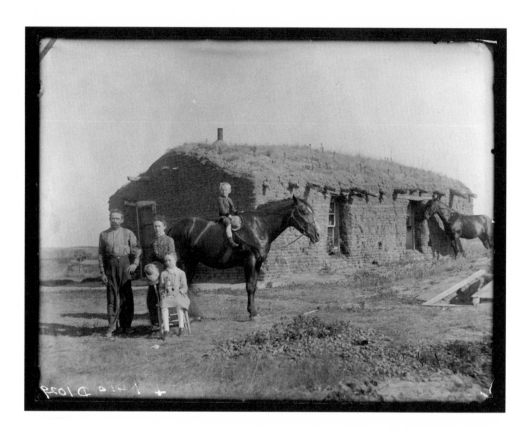

The Newbecker family's homestead.
(NSHS ID: 10169.)

grasslands of America being transformed into farms and towns, and he was passionate about documenting the pioneer days before they vanished forever. He succeeded. Solomon's photograph collection—more than three thousand extraordinary images in all—forms the most complete record of the sod-house era ever made.

He understood the plainsmen he photographed because he was one of them. He had lived through Nebraska's furious blizzards, its burning summer heat, its droughts and dust storms and prairie fires. He had celebrated the Fourth of July with his neighbors and welcomed along with them the song of the meadowlark in the spring. In Butcher's pictures, the pioneers' faces reveal the

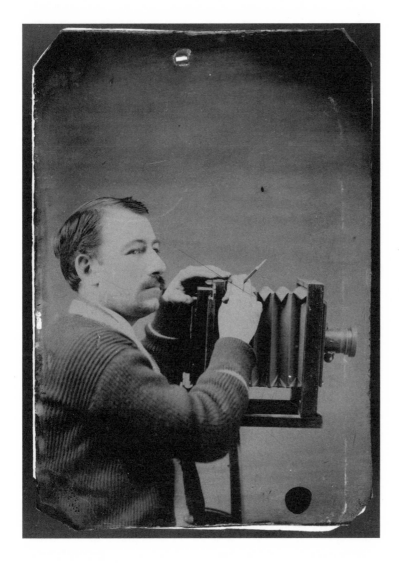

pride and determination they needed to survive in their strange
new land. He himself had the same type of grit, even though he
held a camera more often than a plow.

The Great American Desert

The Great Plains were not always the destination of streams of covered wagons. Early in the nineteenth century, when all the states were clustered east of the Mississippi River, Americans thought of the plains as wild and forbidding, a no-man's-land between East and West. Only a handful of hardy fur trappers and traders ventured out into the region on their way to the Rocky Mountains farther west.

But the Great Plains formed a major portion of the Louisiana Purchase, the land that President Thomas Jefferson had bought from France in 1803. The Lewis and Clark Expedition, organized by Jefferson, explored parts of the unknown territory. As the men of the expedition poled their boats up the churning waters of the Missouri River, they passed along the eastern border of the future state of Nebraska.

More government expeditions went west. In 1806 Lieutenant Zebulon Pike and his men rode through southern Nebraska. The terrain that Pike saw he compared to the "sandy desarts [sic] of Africa."[1] Then in 1820 an army engineer, Major Stephen H. Long, set out for the Rocky Mountains. His expedition was the first to cross Nebraska from one end to the other. On horseback, Long followed the route of the Platte River, Nebraska's main river and the only one that flows across the entire state. After he had passed through the forested eastern third of Nebraska and entered the mostly treeless central region, he agreed with Zebulon Pike about the land. It was not suited to farming—"almost wholly unfit for cultivation," Long wrote, and should be left forever to the Indians and the buffalo.[2] On his map, he labeled the plains country the "Great American Desert"—a name that would stick for years to come.[3]

But it was not a desert to the people who had been there for centuries. It was home. Native Americans had learned to withstand the harsh climate of the plains, and the land and its wildlife provided them with everything they needed to live. Nebraska was named after its main river, the Platte. The word *Nebraska* means "flat water" in the languages of two American Indian tribes.[4] And *Platte*, a name probably first used by French explorers, means "flat" in French. The Platte River valley—and much of Nebraska—does sprawl wide and level for miles. And the central and western parts of the state get little rain. Yet the Indians knew that their land was not a wasteland, but a rich country of many changes.

In the early 1800s several American Indian tribes lived along the banks of the Missouri River, in what is now eastern Nebraska. They were the Omahas, Iowas, Otoes, and Missouria. They built round houses out of earth and timber. In small fields, they planted corn and other crops. Their country was well watered

THE GREAT AMERICAN DESERT

and fertile, with green woods, graceful hills, and high bluffs over-looking the river. Another tribe, the Poncas, lived in a similar way along Nebraska's northernmost river, the swift Niobrara—the "Running Water," the Indians called it. These tribes were semisedentary, because while they kept permanent villages, they also traveled far out onto the plains to hunt.

The Pawnees, Nebraska's largest tribe, ruled the central part of the state. They too built earthen lodges and planted corn. Their villages were scattered along the Platte and Loup rivers, where, in places, shady cottonwood and willow trees grew. Pawnee coun-try also stretched for hundreds of miles beyond the rivers.

Farthest west was the kingdom of the nomads, or wander-ers, of the High Plains—the Lakotas, Cheyennes, and Arapahos. Their homeland included dry grasslands, as well as the Nebras-ka Panhandle. The Panhandle, hinting at the Rocky Mountains to the west, has deep canyons, high buttes, tumbling waterfalls, and forests of whispering pine. The Lakotas and their allies never planted a crop, never stayed long in one place. On fast ponies, they flew across the prairie, raiding other tribes and hunting game.

All the Plains Indians, whether farmers or nomads, hunted the buffalo. The big, shaggy animals were a source of life to the people, giving them everything from meat to warm robes to tools made of bone. There were millions of buffalo feeding on the prairie's rich grasses; one herd alone would cover the land for many miles, like a dark blanket. When the Indians gave chase, the buffalo stampeded. The earth shook, dust clouds swirled, and the shrill yells of the hunters cut the air.

As the young American nation expanded, its people claimed more and more of the Indians' territory. But the U.S. govern-ment thought that no Americans would ever want to live on the Great Plains. So in 1834, Congress designated a large part of the

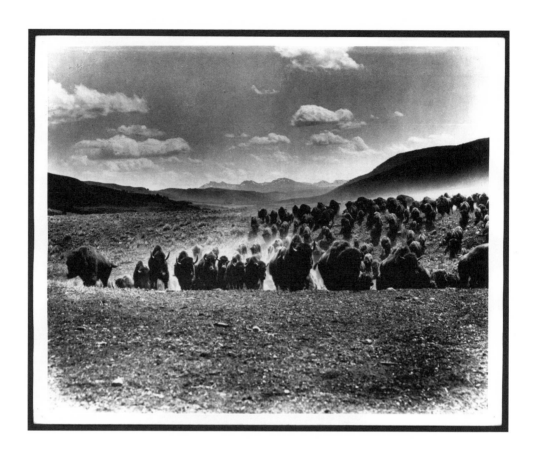

*Herd of charging
buffalo.*
(Photographer
unknown.
NSHS RG: 3211.)

region as permanent Indian country. Settlement there by whites
was declared illegal. Yet "Indian country" was not set aside solely
for the tribes that already lived there. Instead, much of it would
serve as a catchall area for the Native Americans already displaced
from their homes in the East. To make room for these exiles, the
Pawnees and the Missouri River tribes were forced to give up
enormous swaths of their ancestral lands.

So far, the Lakotas, Cheyennes, and Arapahos had managed
to hold on to their country. But these riders of the western plains
watched with growing alarm as white people—Americans—began

THE GREAT AMERICAN DESERT

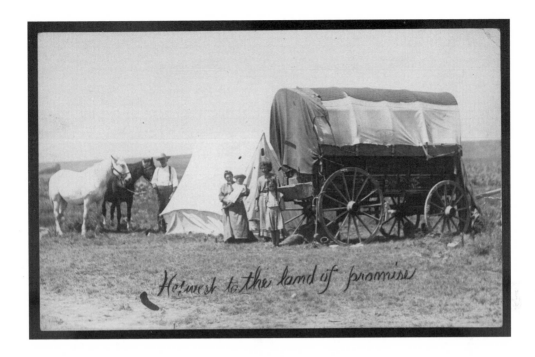

Hei west to the land of promise

driving their wagons through Indian hunting grounds along the Platte River valley, on what came to be called the Oregon Trail.

It began in 1841, when a few wagon trains of emigrants crossed Nebraska on their way to the far West. Each year after that, there were more. Like the early explorers, the travelers followed the Platte because it offered a direct route across the plains. Many of them were bound for the fertile farmlands of Oregon. On their canvas-topped wagons, they painted "OREGON OR BUST." They feared Indian attacks, although there were few. Emigrants were much more likely to die of disease on the journey. But almost nothing stopped a wagon train. If families lost loved ones, they buried them by the trail, said some prayers, and then pushed on.

In 1847 came the Mormons, on their way to find religious freedom in Utah. And in 1848, gold was discovered in California. Hordes of gold seekers took to the trail, and the rush was truly

On the Oregon Trail, heading west to the "land of promise." (Photographer unknown. NSHS RG: 3371.)

13

on. Although small settlements popped up along the Oregon Trail, most of the wagon trains were still just passing through. For these emigrants, Nebraska was "a place on the way to somewhere else," and the Platte valley was simply the best highway.[5]

But the map of the United States was changing; lands in the west were filling in fast. By 1850 Texas and California had become states. Three large new territories—Oregon, Utah, and New Mexico—had also been acquired. Now wagons and stagecoaches rattling over dirt trails were no longer enough to link all parts of the growing country. Americans began dreaming of a transcontinental railroad.

In 1844, Illinois congressman Stephen A. Douglas proposed that such a railroad should, like the wagon trains, follow the Platte route across the Great Plains. But this was the only region not yet divided into states or territories. It would have to be organized politically if the "road" were to be built. At this time, too, the issue of slavery was being hotly debated throughout the country. For the next ten years, northern and southern states argued back and forth: would there be slavery in the Great Plains or not? Finally, in 1854, Congress passed the Kansas-Nebraska Act, which established the two new territories. A compromise to win southern votes, the act left the decision on slavery up to the white people in the territories themselves, a concept called "popular sovereignty." In 1861, settlers in both Kansas and Nebraska voted to ban slavery.

At first, the Nebraska Territory was immense. It included all the land from the Missouri River to the Rocky Mountains and extended north from Kansas to the Canadian border. But with the naming of the Dakota Territory in 1861, Nebraska would be whittled down almost to its present size.

As soon as it was legal for Americans to settle in Nebraska

THE GREAT AMERICAN DESERT

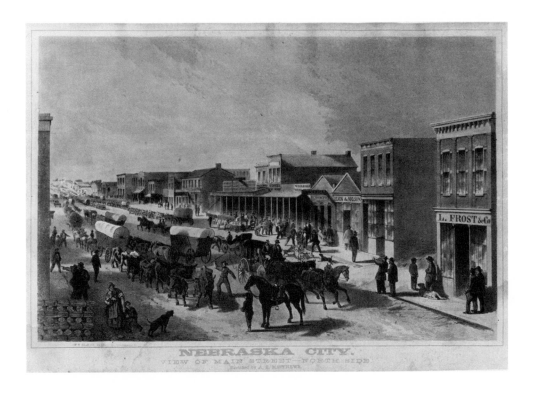

NEBRASKA CITY.
VIEW OF MAIN STREET—NORTH SIDE

and Kansas, they made a mad dash to the territories. Talk of the "Great American Desert" faded away, and emigrants began to call the plains "the Promised Land."[6] Morning and night, ferries crammed with people crossed the Missouri. There were families and singles, gamblers and lawyers, professors and preachers—all seeking new opportunities. The rush looked like a "swarm of locusts," according to one man.[7]

Investors formed town companies and platted, or laid out, new towns almost overnight. Speculators bought and sold property with lightning speed. They advertised lots for sale in grand new cities with names like "Vienna" and "Manhattan."[8] They circulated faked pictures of opera houses and magnificent mansions. The trouble was, many of these cities existed only on paper.

Nebraska City, a thriving town on the Missouri River, in Nebraska Territory. (A. E. Matthews. NSHS SFN: 105020.)

15

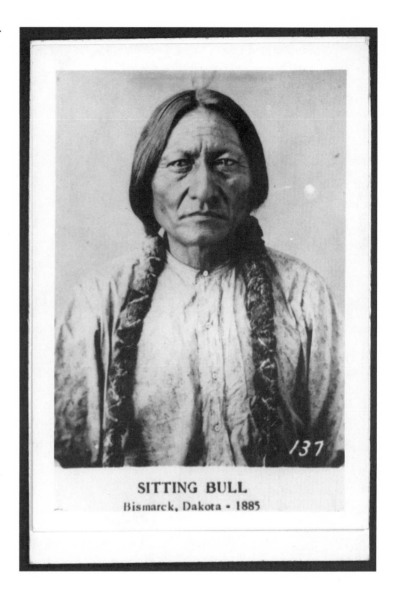

The great Lakota leader
Sitting Bull, in 1885.
(David Francis Barry.
NSHS RG: 2063.)

SITTING BULL
Bismarck, Dakota · 1885

People who bought lots often arrived to find nothing but a few shacks and some pigs rooting in the mud. Sometimes they found nothing at all. Still the building boom raged on, and real towns did get built. As one newcomer said, "We felt richer, better, and

THE GREAT AMERICAN DESERT

more millionairish than any poor deluded mortals ever did on the same amount of moonshine and pluck."⁹ Everyone hoped to be near the transcontinental railroad when it finally came through. Wherever the trains went, people reasoned, business and prosperity would surely follow.

When the Kansas-Nebraska Act was signed, the idea of a permanent Indian country disappeared like a wisp of smoke. Throughout the 1850s the government was hard at work negotiating treaties with Nebraska's Natives, steadily chipping away at their lands. By the end of the decade, the Pawnees and other river tribes had given up almost all of their country and were living on small reservations in Nebraska, thin slices of their former homes. And by the early 1880s most of these people would be sent away entirely, to a new catchall area—a place called "Indian Territory," in the future state of Oklahoma.

Farther west in Nebraska—and in Colorado, Wyoming, Montana, and the Dakotas—the Lakotas and their allies put up a fierce fight for their freedom. They won major battles against the U.S. Army and raided white settlements in a wide area, including those along the Platte. Yet in 1881 the great Lakota leader Sitting Bull would become the last warrior of his tribe to surrender his rifle. When his people too ended up on reservations, there would be almost no free Indians left on the plains.

By this time, the buffalo, once lords of the prairie, were almost gone. They had fallen by the millions to the high-powered rifles of white hunters. Only their bones were left, hidden in the tall grass and scattered over the land.

Many years after his exile to a reservation in Indian Territory, a Pawnee chief named Gray Eagle came back to Nebraska to visit the place of his birth. "I stood upon the very spot where I was

born, and as I looked out over the slopes and valleys that had once been ours," he said, ". . . my heart was very sad."[10]

The Plains Indians, the original Nebraskans, had tried to keep the whites from taking their land, but it was like trying to hold back a river.

Solomon Butcher, Sodbuster

The river of settlers flowed swiftly, and from the end of the Civil War in 1865 to about 1890, it resembled a flood. Under the Homestead Act of 1862, immigrants claimed about eighteen million acres of land in Nebraska alone. Government surveyors worked as fast as they could but could hardly keep up with the demand. All a homestead cost was a ten-dollar filing fee—and five years of backbreaking farmwork. Whether prepared for the work or not, the pioneers all had one thing in common—their desire to own land. As one young woman wrote, "Every lick we strike is for ourselves and not half for someone else. I tell you this is quite a consolation to us who have been renters so long. There are no renters here."[1]

In 1865 the Union Pacific Railroad, the eastern half of the transcontinental train, started chugging across the plains. Construction began in Omaha, Nebraska, and it was the biggest, boldest project

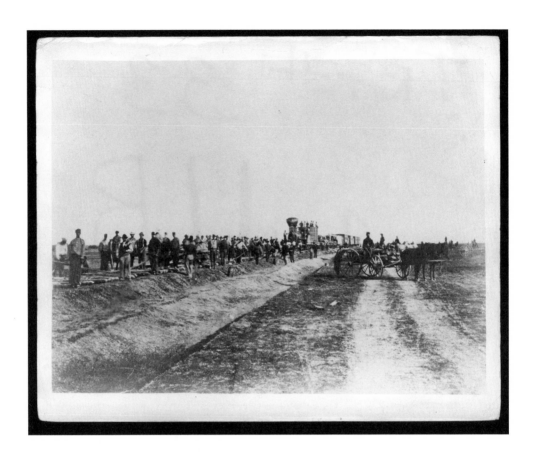

Tracklayers at work, building the Union Pacific Railroad. (Photographer unknown. NSHS RG: 3761. Union Pacific Railroad collection.)

of the century. Building the road required millions of trees, countless tons of iron, and the sweat and muscle of ten thousand men. As Stephen A. Douglas and other politicians had hoped, the tracks followed the path of the Platte valley, the old Oregon Trail. In Utah, in 1869, the Union Pacific joined the Central Pacific Railroad, which had come from California. East was finally connected to West.

The federal government had granted the Union Pacific huge tracts of the best public-owned land on both sides of the track. The railroad company then sold much of this land to settlers. This was another way, in addition to filing homestead claims, that immigrants

SOLOMON BUTCHER, SODBUSTER

could acquire property. It also helped the railroad pay its construction costs. Millions of acres changed hands, largely because the Union Pacific launched a massive advertising campaign, both in America and Europe. So as the train steamed across the prairie, towns and ranches and farms sprang up along its route. The population of Nebraska Territory, which was under three thousand in 1854, surged to fifty thousand by 1867. That year, Nebraska became the thirty-seventh state. The new state's capital, a little village named Lancaster, was renamed Lincoln to honor the president who had led the country through the Civil War.

Many thousands of emigrants came to the Great Plains from countries in northern Europe—England, Germany, Bohemia, Sweden, Russia, and more. Those who didn't speak English often came over and settled together in colonies, where they could keep the old customs alive. Still, most of the newcomers were American born. Civil War veterans, given special land grants, flocked to the plains to start a new life after the chaos of the war. Probably no group was more passionate about starting over than African Americans from the South. Although they had been freed from slavery, they were being persecuted and deprived of political rights in the postwar period. In 1879 the governor of Kansas reported that a group of former slaves had told him that "they had rather die in the attempt to reach the land where they can be free than to live in the South any longer."[2]

But the majority of American emigrants were from states in the East, such as Pennsylvania, Ohio, Iowa, Illinois. Solomon Butcher was one of these eastern pioneers.

He was born in the town of Burton, West Virginia, on January 24, 1856, the first child of Esther and Thomas Jefferson Butcher. His family would grow to include four more children—Marinda, Anna, George, and Abner, or "Ab." When Solomon was four, the Butchers moved to Winona, Illinois, where Thomas took a job

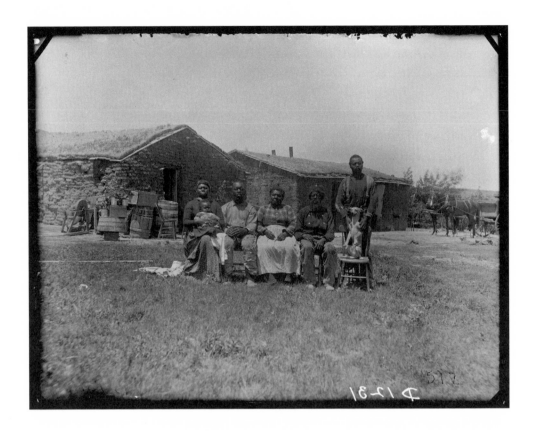

The Jerry Shores family, who were former slaves. Jerry Shores's brothers, Moses Webb and Henry Speece, claimed neighboring homesteads in Custer County. (NSHS ID. 10527.)

with the Illinois Central Railroad. Mr. and Mrs. Butcher were unusual for their time because they made sure that each of their children received a high school education. When Solomon was eighteen, he worked briefly for a man who made tintypes, an early type of photograph made directly on a sheet of iron metal. This was his first experience with photography.

Next he enrolled at an Illinois military school. After one term there, he left to embark on a career as a traveling salesman. From 1876 to 1880, Solomon walked from house to house, selling patent medicines and giving sidewalk demonstrations of his cure-all potions.

The young salesman was earning a good salary, $125 a month,

and living on his own in a boardinghouse when he received a surprising letter from his father. After twenty years with the railroad, Thomas had come down with a case of western fever. He dreamed of claiming a free homestead across the Missouri for his family, and the place he had chosen to do this was Custer County, Nebraska. Bored after four years of knocking on doors, Solomon himself had thought about going west. He said yes to the adventure. Now the Butchers had to select their land. Solomon, his father, his nineteen-year-old brother George, and his brother-in-law John Wabel took that first trip.

It was "roughing it with a vengeance," according to Solomon.[3] The men started out on March 9, 1880, in bone-chilling cold. Their two wagons rolled from dawn to dusk. In the beginning, Solomon was shaking with fever, too sick to eat. This didn't excuse him from work, though. "I was unanimously elected cook (as I was popularly supposed to be good for nothing else)," he wrote.[4] Thomas woke the young tenderfoot before dawn every pitch-black morning to start the breakfast fire. Luckily, by the time the pioneers reached Custer County in late April, Solomon had recovered his health. "I had an appetite that made a crust of dry bread taste like plum pudding."[5]

Although the Homestead Act and the railroad had brought a population boom to Nebraska, most of the settlers were bunched in the eastern part of the state. Homesteading—farming—was more difficult in the central and western regions, where rainfall was low and timber scarce. So Custer County—named after George Armstrong Custer, the U.S. Army officer famous for fighting the American Indians—was wide-open frontier when the Butchers arrived.

How different it was from their home in Illinois! It was a place where one could easily get lost. They gazed at the land, which rolled on for miles in every direction, like long ocean swells. The

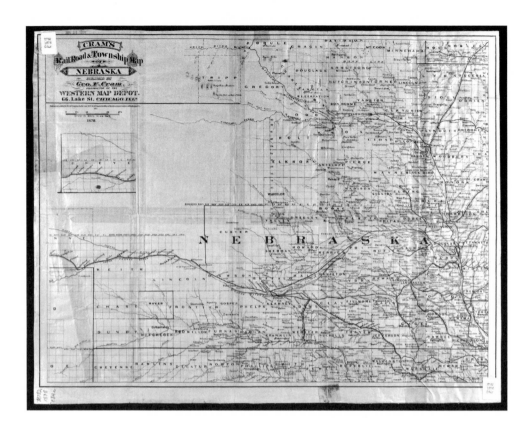

Map of Nebraska in 1878, two years before the Butchers arrived. (Georg F. Cram. NSHS ID. 44201.)

big sky reached down to the far horizon, and when night came, the men had never seen such a spangling of stars.

Government surveyors had divided public land into a checkerboard of sections—one square mile, or 640 acres, each. Every homesteader was permitted one quarter section, or 160 acres. Solomon and his father chose their quarter sections near the small settlement of Gates, on the winding Middle Loup River. Like most newcomers, they probably marked the corners of their land with wooden stakes. On Thomas's property, the men dug a well so they wouldn't have to haul barrels of water from the river. They were happy to find clear water only twenty feet below

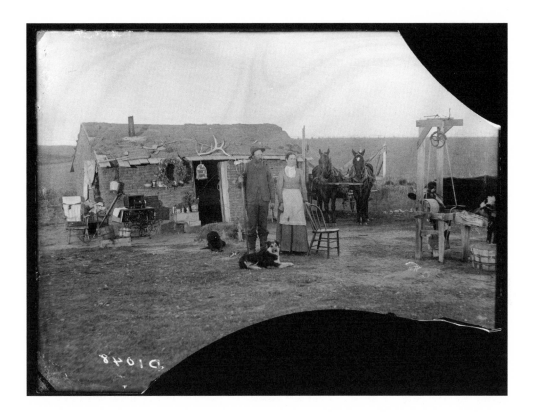

the surface—good luck in a region where some wells had to be
dug hundreds of feet deep. Then they hurried to file their claims
at the nearest government land office, which was in the town of
Grand Island, ninety miles to the south on the Platte River. Sol-
omon's married sister, Anna Wabel, met her family members in
town. It was a relief to all when she agreed to take over from Sol-
omon the job of household cook.

Back on Thomas's claim, the men dug a temporary shelter,
which Solomon described as a "hole in the ground."[6] Their wag-
on cover served as a roof. Then the Butchers began to think about
a more permanent house. While settlers in eastern Nebraska had

*"Nebraska Gothic," the
John Curry sod house.*
(NSHS ID. 10236.)

timber to build with, those in Custer County had to use sod. Sod didn't cost anything, and it was everywhere. It was just the top layer of soil, along with grass and tangled grass roots. The pioneers called it "Nebraska marble," and they called themselves "sodbusters." An earthen house, as the Pawnees knew and the settlers learned, was the perfect solution to life on the treeless prairie. There were sod houses—and barns and banks and schools—all over the Great Plains, but more were built in Nebraska than anywhere else.

First the Butchers selected a piece of land with a thick growth of grass. Then they used a specially designed, horse-drawn grasshopper plow to collect their building material. The plow sliced under the sod and peeled it up in strips, each about one and a half feet wide and several inches thick. The strips were then cut into sections about three feet long. Big bluestem grass, "king of the prairie grasses," made the best sod strips because its densely entwined roots held the soil together.[7]

At the building site, wrote Solomon, "I took my first lesson in sod laying, which resulted principally in wearing out my hands and my patience."[8] The Butchers laid the strips grass side down in layers to build their house—two such layers placed side by side made walls that were three feet thick. The men took care to keep walls and corners straight so that the heavy earth would not collapse under its own weight. As the walls rose higher, they added wooden frames for windows and a door. Any gaps in the sod bricks were later filled with clay and dirt.

They used most of their hard-to-find wood for the roof—a long center ridge pole and rafters that connected the pole to the walls. They laid brush, grass, and a layer of sod over the rafters, then topped the roof with wooden planks. They may have placed another layer of sod over these planks for added insulation, as many builders did. The Butchers' roof was more advanced than

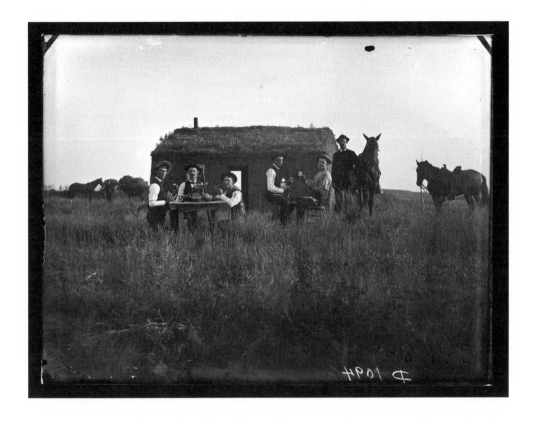

those of earlier soddies. The more primitive roofs had no wooden planking at all, only layers of sod, brush, and grass. A mass of wildflowers sprouted from roofs like these. When the writer Mark Twain visited the plains, he noted, "It was the first time we had ever seen a man's front yard on top of his house."[9]

The Butchers completed their soddy in mid-May. But eight days before they finished, they ran out of food and were forced to eat their horses' fodder. It had a slight flavor of kerosene, due to an unfortunate spill. Solomon couldn't help comparing his past in Illinois with his new life as a sodbuster: "I soon came to the conclusion that any man that would leave the luxuries of a

The four Perry brothers in front of their soddy. (NSHS ID. 10349.)

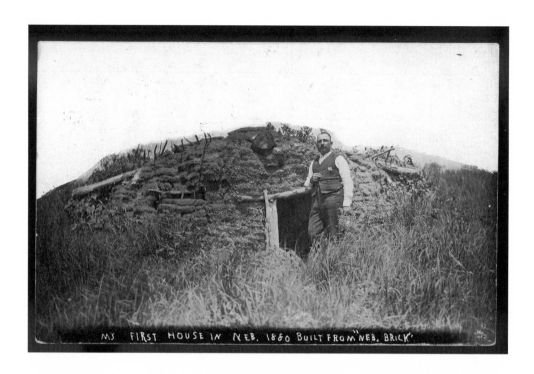

MS FIRST HOUSE IN NEB. 1880 BUILT FROM "NEB. BRICK"

Solomon Butcher's dugout, 1880, his first house in Nebraska. (NSHS ID. 10216.)

boarding house where they had hash every day, and a salary of $125 a month to lay Nebraska sod . . . was a fool."[10]

Now that the house was ready, it was time to gather the rest of the family. While John Wabel drove the wagon to Grand Island for supplies and George stayed on the claim to plant corn, Solomon and Thomas returned to Illinois to bring Solomon's mother and his youngest brother, Ab, back to Nebraska.

But when his family members headed back to Custer County, Solomon stayed on in Illinois. He stayed so long that he almost lost his 160 acres in Nebraska. The Homestead Act allowed a person six months in which to build on a claim, but if there was no house after that period, the government took back the land.

Solomon rushed back with only three days to spare. Anxious to make the deadline, he spurred an "old cow pony" from Grand

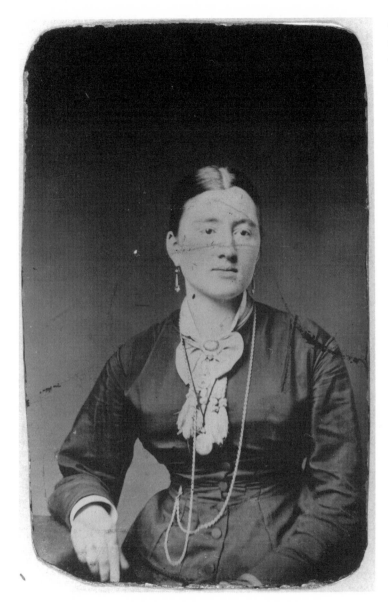

A tintype of Lillie Barber Butcher, Solomon's wife. (NSHS ID. 3215.)

Island to Custer County. It was a shaky ride on the elderly horse. "Every step he made was likely to kill me," wrote Solomon. "I wished more than once that the claim was more than 2,000 miles away, so that it would be no use in my trying to get there."[11]

On the last day, his father and brothers, along with a team of strong oxen, helped Solomon build his house, and by nightfall it was ready for him to sleep in. It was a dugout, a glorified hole scooped out of the side of a hill, the type of shelter used by many pioneers before they built proper soddies. Solomon had narrowly missed losing his claim. A "kind neighbor" had been keeping close watch on Butcher's homestead, ready to grab the land, to jump Solomon's claim, at the first possible minute.[12]

Dugouts could be seen all over the prairie, tucked into hillsides or the high banks of streams. But sometimes they blended in so well that they could not be seen at all. Cows grazed on their roofs. Riders on horseback trotted over them too. One pioneer told Solomon that once, on a nighttime ride, he had mistaken the stovepipe of a dugout for a fence post. He and his horse broke through the dugout's roof, landing amid an outraged family. "Who's there? Get out! Scat! . . . Get the gun!" cried the family members from their beds.[13]

Sitting in his dugout, Solomon wrestled with one hard fact. If he wanted to secure his government patent, or final ownership of the land, he would have to farm it for the next five years. Just the thought of this made the young bachelor feel lonely. As he later wrote, "I would not have remained and kept batch for five years for the whole of Custer County."[14] After only two weeks on his claim, he gave it back to the government. He composed a little ditty, "Farewell to My Homestead Shanty," to mark the occasion:

Farewell to my homestead shanty;
I have my final proof;
The cattle will hook down the walls,
And someone will steal off the roof.[15]

Thrashing around for new career ideas, he thought he might become a doctor. He enrolled in the Minnesota Medical College in Minneapolis. That didn't suit him either, and after two semesters, he dropped out. But during his medical studies, he had fallen in love with a young widow, a nurse named Lillie Barber Hamilton. The two were married on May 16, 1882.

And once again Solomon felt the pull of the boundless prairie. "I had just seen enough of the wild west to unfit me for living contentedly in the East."[16] On October 20, 1882, he returned with Lillie to Custer County and drove his wagon to his father's sod-house door.

"Eureka!"

Solomon Butcher was still a pioneer who didn't like farming, and he hoped to do as little of it as possible. He and Lillie lived with his father that winter, while Solomon taught school and earned enough money to buy a new farm. Under an 1841 law called the Preemption Act, he was able to buy land from the government for $1.25 an acre. He and Lillie built a little house that they moved into in June 1883. Solomon, who had never forgotten his early training in photography, borrowed money to buy a camera. He turned the house into a "photograph gallery," or studio—the first one in Custer County.[1]

"Such an outfit!" Solomon later joked. "It made us sick at heart. We often wondered what some of our stylish friends back east would think if they should peep in and see us. They would probably have thought we were crazy."[2] The combination home-studio

was really just a shack. It had a dirt floor and cloth on the windows because Solomon couldn't afford glass. By now, he and Lillie had a baby boy named Lynn. They had to rig a kind of tent over the baby's bed because the roof leaked so badly when it rained. And in a real storm, they wrapped Lynn in a quilt and ran to Thomas's house for shelter.

Solomon kept busy trying to scrape together a living. He worked on his father's farm for fifty or seventy-five cents a day. He also established a post office in his house, although his profit from selling stamps in the first three months was only sixty-eight cents. This, he quipped, put him on "the high road to success."[3] And he made tintypes of other settlers—the only work he really enjoyed—using an old rat-eaten wagon cover as a studio backdrop. "Whenever anyone wanted a tintype I dropped my hoe and made it, and went back to the field again."[4]

The Butcher children, Madge and Lynn.
(NSHS ID. 3211.)

In fall 1883, he built a sod addition to the original shack. It had a better roof, so at least the Butchers could stay home in bad weather. Solomon also added another 160 acres to his farm by taking a timber claim. The Timber Culture Act of 1873 granted homesteaders an additional quarter section of land, provided they use a certain portion of it to plant trees.

Solomon and Lillie's second child, a girl named Madge, was born in September 1884. The house–studio–post office was even more crowded now. Solomon took a partner, a man named A. W. Darling, into his photography business, and together they built another studio, in a new town called Walworth. It was the kind of town, Solomon said, that was springing up on the plains "like the mushrooms that come up in the night."[5]

But soon Walworth itself failed, as many upstart prairie towns did. Butcher and Darling relocated nearby, to the town of West Union. And somehow, they kept the business alive. Yet many people thought it strange that Solomon insisted on sticking to photography. "My friends advised me to go on my farm and go to work," he wrote. "This was an insinuation that rather nettled me. It seemed to suggest that they thought that I was afraid to work. This is a mistake. On the contrary I could lie down and go to sleep alongside of it at any time."[6]

He was a dreamer. And in 1886, when he was thirty years old, he dreamed up the idea that changed everything. He called it his "history scheme."[7] He planned to travel through Custer County taking pictures of his friends and neighbors, the pioneers. He would collect their reminiscences, too, and combine photographs and writings in one book. But first he had to work out the details. "I laid out plans and covered sheet after sheet of paper, only to tear them up and consign them to the waste basket. At last, Eureka! Eureka! I had found it."[8] He was so excited that he couldn't sleep for a week.

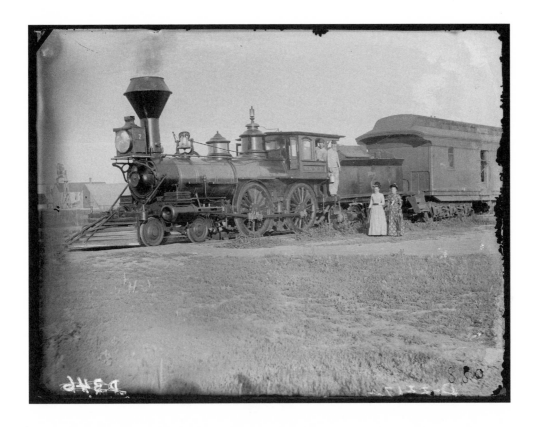

The first train into Broken Bow, the Custer County seat.
(NSHS ID. 12653.)

Since he had first come to Nebraska, Solomon had watched Custer County change from empty frontier to a place that was settling up fast. The same year that he thought of his history scheme, the Burlington and Missouri River Railroad came to Broken Bow, the county seat, for the first time. Every day, the train brought in more people and goods from the outside world. The era of sod houses in the wilderness was disappearing fast, and Butcher wanted to tell its story while there was still time.

First he had to ask his father to lend him a wagon and team of horses, because he was too poor to buy his own. Thomas, a hardworking farmer, had his doubts. But when Solomon quickly lined up seventy-five customers for photographs, Thomas agreed

Solomon Butcher's picture wagon, with his brother Ab driving. (NSHS ID. 10010.)

to the loan. So Solomon bolted a large black box—his "photographic laboratory," or darkroom—to the back of the wagon.[9] Then he hitched up the horses and took to the prairie.

It was June. Rippling grasses under a clear blue sky, and the wild roses sent their sweetness out onto the breeze. There were almost no roads then and no bridges across the streams. Travel was slow. Solomon's horses pulled his picture wagon over Custer County's changing terrain—flat tablelands, hills and valleys, canyons carved deep by creeks. The wandering photographer saw deer and antelope, prairie dogs and prairie chickens, and when

"EUREKA!"

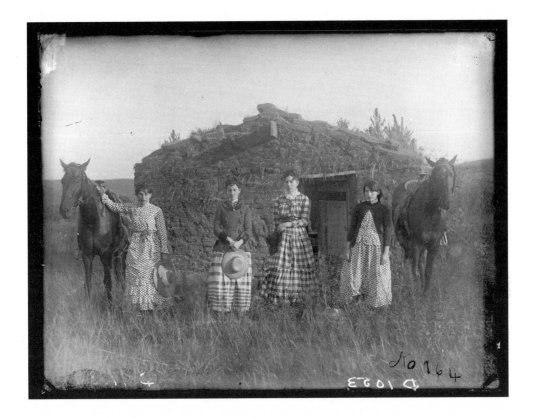

he camped at night, he heard the coyote's eerie howl. He stopped wherever he found a farm or ranch, and his visits were always welcome. How else but with a photograph could the pioneers show their new life to the folks back home? Solomon supported himself by selling his pictures and subscriptions to his future book. He took small donations, and he bartered—a free photo in exchange, perhaps, for a meal or a place to sleep.

His camera was heavy, made of wood and metal. Instead of photographic film, Butcher used individual glass-plate negatives measuring six and a half by eight and a half inches. These fit into the back of the camera and were coated with chemicals that reacted when exposed to light. After recording an image, a negative

was printed out on special paper to create a finished photograph. But glass-plate negatives were not light sensitive enough to capture images very quickly. The photographer's subjects had to hold their breath and stand still to prevent blurring. Those who couldn't keep still, such as dogs and babies, sometimes ended up looking as if they had two heads.

One of his first photographs was of his neighbors, the Chrisman sisters. They were known by their nicknames—Hattie, Lizzie, Lutie, and Babe. Their family had come to Custer County in 1883, and the girls had cried to see such a "desolate" place.[10] But their father had since become a successful rancher, and the sisters were ranchers now too, herding cattle on horseback for hours of the day. The three eldest girls had used the land laws—Preemption, Homestead, and Timber Culture—to acquire big parcels of property, 480 acres apiece. For this picture, Solomon posed the Chrismans in front of Lizzie's sod shanty, put up to secure one of her claims.

During Butcher's first few years in Custer County, sod houses multiplied on the prairie. They were not all alike. There were hundreds of variations in quality, size, style. Some soddies had crumbly, sagging walls and roofs that looked as if they needed a haircut. Others were arrow straight, with sharp corners and neat shingles. With few windows and thick walls, soddies were dark inside. Settlers often brightened the interiors with plaster and whitewash, even wallpaper. Pots of flowers in the deep windowsills added splashes of cheer. People decorated the outsides of their houses, too, with elk or deer antlers and bird cages that they hung by the door.

Many soddies were tiny, twelve by fourteen feet or even smaller. These consisted of one room, partitioned with sheets or blankets. Furniture was usually homemade or improvised—an overturned crate served as a table, a wooden plank became a bed.

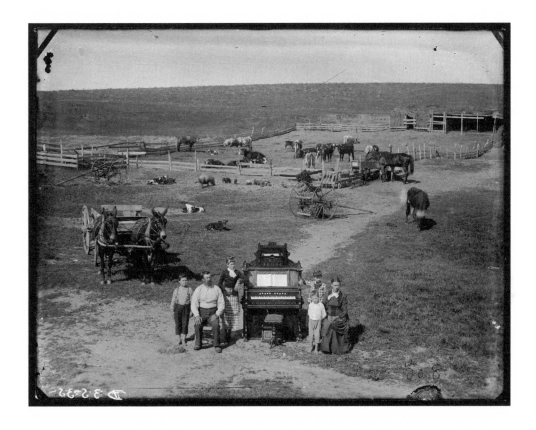

Pioneers also brought treasures from their old homes. One of Butcher's pictures was of the Hilton family, immigrants from England. They are posed around Mrs. Hilton's prized possession, her ornate pump organ, but the family house is nowhere to be seen. Mrs. Hilton was ashamed of her humble soddy and had refused to include it in the picture.

The Hiltons and their pump organ. (NSHS ID. 14567.)

As soon as they were able, most settlers added lean-tos and additions to their houses to expand their living space. At least one house that Butcher photographed was a sod palace.

It was a two-story mansion, built in 1884 by the Isadore Haumont family, immigrants from Belgium. It boasted five rooms, interior wood paneling, a double window, even a brick chimney.

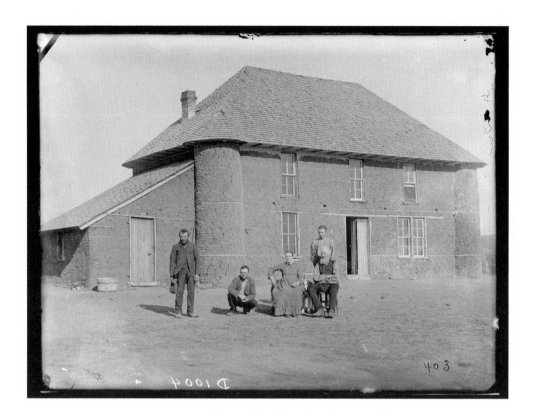

At a time when a soddy could be built for under $5.00, the Haumont house cost a staggering $500, and it remained standing for almost one hundred years.

Most earthen houses leaked in the rain. Water trickled down people's necks. Gobs of mud splashed into the cooking pot unless the woman of the house stood over the stove with an umbrella. And if the soddy had a dirt floor, as most did, the cook had mud stew under her feet as well. Even two or three days after a rain, it was drip, drip, drip inside. Pioneer women got used to dragging all their belongings outside to dry in the sun. Cave-ins were a constant worry, too. Solomon took a picture of one man, a widower named George Barnes, and his three motherless

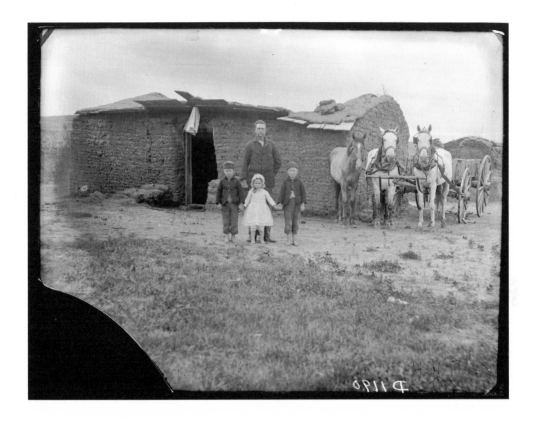

children the day after rain had caused their roof to collapse—just minutes after they had left the house.

The outdoors came indoors in more ways than rain. Mice, rats, insects, and snakes liked to nestle in sod roofs and walls. Often, they dropped in to pay a visit. As Butcher collected pioneer stories, he received many about the settlers' struggles with prairie critters.

One man noted that no history of Custer County should be written without mention of the flea, that "enemy of the settlers." Fleas were everywhere, he wrote, and they were "on the warpath." They were in his blankets. They were in his clothes. They even assaulted him at church. "All had to scratch, and it was not

"Three motherless children and a caved-in soddy."
(NSHS ID. 10002.)

41

considered impolite to scratch any particular part of your anatomy that happened to be bitten."[11]

There were bedbugs too—"enough to stampede a flock of cowboys," noted one man.[12] But the worst problem was rattlesnakes. One farmer killed twenty-seven while plowing his field. Another related a childhood incident: When he went to wake his sister one morning, he saw a large rattlesnake coiled at her throat. He froze, unable to speak. His mother, standing beside him, froze too. At last the snake slithered off the girl's bed and disappeared through a mouse hole in the wall.

"Life is too short to be spent under a sod roof," concluded one woman.[13] Others found humor in the situation and put it in a song called "Starving to Death on a Government Claim":

How happy I am as I crawl into bed,
The rattlesnakes rattling a tune at my head,
While the gay little centipede, so void of all fear,
Crawls over my neck, and into my ear.
And the gay little bedbug, so cheerful and bright,
He keeps me a-going two-thirds of the night.[14]

In spite of the critters, there were advantages to living in a sod house. Sod was excellent insulation, so soddies were warmer in winter and cooler in summer than frame, or wooden, houses. Soddies were more resistant to fire. And much more resistant to the prairie wind, which in winter turned ferocious. It could snatch off roofs, overturn wagons, send chickens hurtling through the air. Those were the times when people were grateful for their cramped but cozy houses of dirt.

In Solomon Butcher's time, the pioneers of the Great Plains would turn millions of acres of prairie into lush fields of grain. Farmers discovered that the soil that nourished the native grasses was

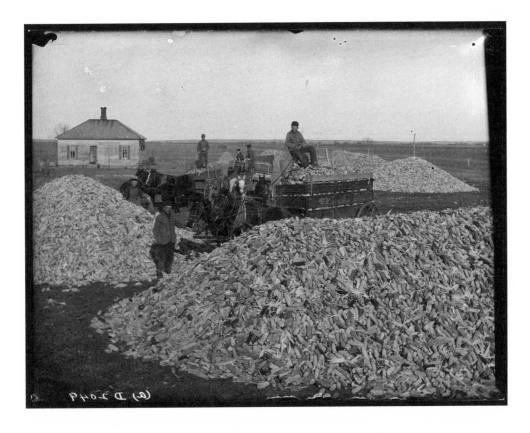

very fertile, "rich as cream."[15] Without tree stumps, the earth was easy to plow. And an abundant supply of underground water helped keep crops alive in times of little rain. In the 1870s, new farms began to spread across Nebraska. But the 1880s were the years of the most spectacular growth in state history. The population doubled, and so did the number of farms. Farmers increased food production beyond what they needed just for their families, and with the help of the railroads, they sold crops to an expanding network of markets. Only recently a lonely frontier, Nebraska became one of the top food producers in the nation.

The first and most important crop was corn. So much was produced in Nebraska and other parts of the Midwest that the region

A good corn harvest.
(NSHS ID. 12479.)

43

came to be called the "Cornbelt." Butcher photographed the sodbusters as they worked in the fields with their horse-drawn equipment. First they plowed, turning over the sod and carving long furrows in the ground to ready it for the seed. In the greening of spring, they planted. Over the summer, they watched the corn grow tall and they prayed for rain. The fall, golden and mellow, was harvest time. When the harvest was good, most of the corn was sold and shipped by rail. The rest fed livestock and families. Cornbread, corn muffins, cornmeal mush, corn cakes, corn pudding—many Nebraskans got tired of eating corn!

They grew wheat, oats, rye, and other grains, too. Fields of sorghum, a special type of grass, provided sorghum molasses—good for sweetening all that cornbread. The settlers planted fruit orchards; and in vegetable gardens, they tended pumpkins, potatoes, beans, and many kinds of melon. Butcher took pictures of pioneers enjoying slices of juicy, homegrown watermelon, a favorite treat.

Photography was a fairly new invention in Butcher's day, and people were fascinated by the camera's ability to preserve a single moment in time. Photographers walked the battlefields of the Civil War; and afterward, they documented the settling of the West—the first major historical movement to be photographed. Yet while there were many other itinerant photographers on the plains along with Butcher, none of them had a history scheme as sweeping as his. And none of them covered as many miles. On his quest to photograph the pioneers, he would visit more than a dozen Nebraska counties and even other states. But he concentrated mostly on Custer County, his home. The scenes that he recorded there represent well the larger pioneer experience. Life throughout Nebraska and on the plains of Kansas and the Dakotas was very much the same.

Solomon was on a serious quest, but he had fun with it, too.

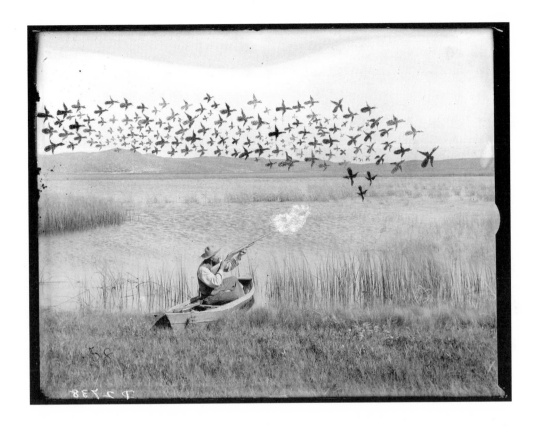

If he couldn't get a detail that he wanted in a picture, he used ink or a sharp tool and drew it on the negative himself. This was the only way, without blurring, that he could show a flock of ducks in flight. And the only way he could show trees, flowers, even rabbits that were not actually there.

At least once, his sense of humor helped him out of a jam. One day, he accidentally poked a hole in a negative. To cover up the damaged spot, he painted a large turkey over it, then printed the photograph. Years later he wrote about what happened when he showed the picture to Theodore Hohman, the farmer who had ordered it: "Mr. Homan said, 'What is that?' The photographer trembling in his shoes remarked 'Looks like a turkey.' Hohman

Butcher drew ducks in flight on his negative. (NSHS ID. 13546.)

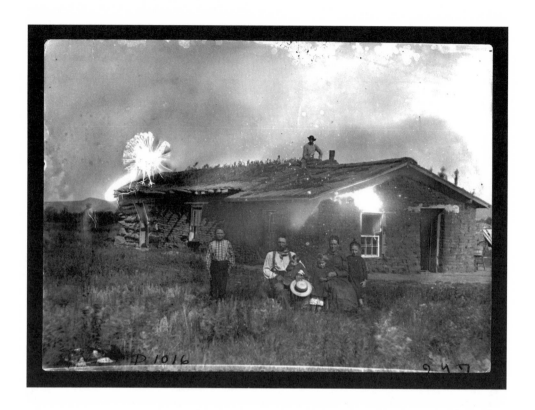

"The Power of Suggestion," or the Turkey That Wasn't There. (NSHS ID. 2836.)

said it couldn't be as the turkeys were not around. Besides they did not have any white ones. His wife spoke and said, 'Yes Theodore don't you remember me telling you to drive the turkeys away.' That settled it. But to this day I expect Hohman wonders where that old white gobbler came from."[16]

Solomon entitled this picture "The Power of Suggestion."

Attack of the Grasshoppers

Butcher advertised for his book, requesting histories and "thrilling stories," and he got them.[1] Everyone who had come to the new land had a story to tell. People sent hundreds of letters and manuscripts, and they told him more true tales of the frontier when he visited their homes.

The photographer dropped in on his good friend Ephraim Swain Finch at his ranch on the South Loup River. Finch, whom everyone called "Uncle Swain," was one of the area's most prosperous ranchers. He had come to Custer County in 1875, and he liked to talk about the old days. The seventies had been a hard decade on the plains. In addition to suffering from a nationwide financial depression, the settlers saw years of drought, and there were times when they feared Indian attacks. These never came, but the pioneers did have to face a different kind of enemy—grasshoppers.

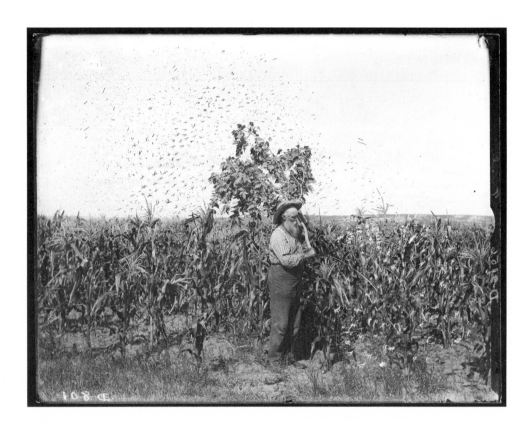

Uncle Swain Finch reenacts a grasshopper invasion.
(NSHS ID. 12600.)

Uncle Swain described an invasion that took place in the spring of 1876. He had seen what at first looked like thick smoke on the horizon. As the smoke came closer, it darkened the whole sky. Finch began to hear "a continuous cracking and snapping sound, which increased to a perfect roar." Then they landed—millions and millions of grasshoppers, with brown backs, pale bellies, glistening wings. Within seconds, Finch recalled, "every green thing in sight was literally covered and hidden with a seething, crawling mass several inches in depth." He could hear their jaws chomping as they demolished his crops. Horrified and disgusted, Finch started whacking at the insects with a willow branch. He killed thousands, but he could not kill them all. They ate his

whole field of corn and everything else on his farm, "leaving it as brown and bare as if it had been swept by fire."[2]

Butcher asked Uncle Swain to reenact his battle with the grasshoppers for a photograph. In the picture, Finch poses in his cornfield, brandishing a willow. Even though it is long after the actual event, he is surrounded by a swarm of grasshoppers. Always creative, the photographer has sketched the insects onto the negative.

From 1874 to 1877, grasshoppers periodically swept down onto the plains. Even cattle fled before them. And when they landed on train tracks, their bodies made the rails so greasy that the trains couldn't run. From Texas to the Dakota Territory, grasshoppers devoured not only crops but also tree bark, fence posts, lace curtains, leather boots. The invasions were especially ruinous for new farmers who had planted their fields for the first time; they had no extra food stored to get them through the winter. The grasshoppers even burrowed underground to get at the potatoes. The federal government, individual states, and private charities sent food and supplies to the Great Plains. Even so, many settlers gave up and left. A sign on one wagon read: "Eaten out by grasshoppers, Going back East to live with wife's folks."[3]

Then, after 1877, the hoppers mysteriously stopped coming.

Instead, the Butcher family arrived in Nebraska in time to experience another trial, the hard winter of 1880 to 1881. It was one of the worst winters in plains history. Solomon's brother Ab was fifteen at the time, and he later wrote an account. The first blizzard flew in early, Ab remembered. Soon that snowfall melted, only to freeze again and cover the land with a sharp crust of ice. All winter this pattern continued, along with howling winds and temperatures dropping to forty-five degrees below zero. With drifts as high as twenty feet, horse-and-buggy outfits couldn't move. All travel had to be done on foot, so Ab wrapped his feet in rags and sacks to prevent frostbite. Most of the cattle, horses,

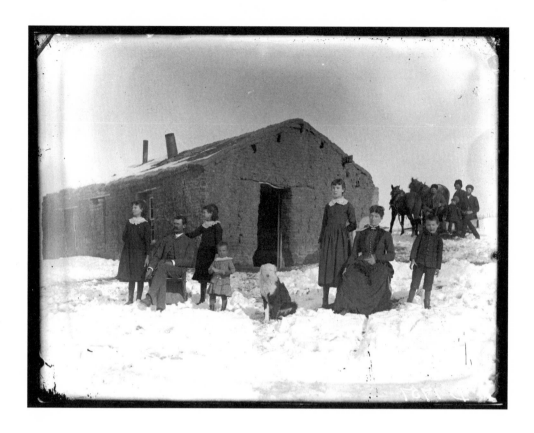

Winter in Cherry County, Nebraska.
(NSHS ID. 11234)

and sheep left out on the open range froze or starved to death, unable to paw through the ice to reach grass. When spring finally came, Ab saw dead cattle piled up along the Middle Loup River, where they had gone in search of food. Their bodies were "so thick that you could jump from one to another."[4]

Some lone blizzards were so fierce that they became part of Nebraska history. They often struck without warning, catching people out on the prairie. Those lucky enough to be home often brought their horses or cows into their houses so the animals wouldn't freeze. Snow swirled so thick that it was hard to breathe, impossible to see. A farmer could get fatally lost just going from house to barn if he didn't tie one end of a rope around

ATTACK OF THE GRASSHOPPERS

his door handle and the other end around his waist.

Early pioneers talked about the Easter blizzard of 1873. It began on a springlike holiday afternoon and ended with many people dead. One family of seven was found frozen in bed. Then there was the schoolchildren's blizzard of 1888, so named because it began while the children were at school. At recess, storm clouds approached, and it grew dark enough to light the lanterns. The temperature dropped twenty degrees in twenty minutes as a wicked wind and driving snow swept down on the prairie. Many teachers were stranded with their students. When they ran out of fuel, they kept the children from freezing by burning the furniture. Some teachers formed a human chain with their charges and were able to lead them to the warmth of the nearest farmhouse. "Babe" Chrisman was a young teacher at the time. She let her horse Jessie, who stands next to her in Butcher's photograph, lead her and her pupils home. Yet some, teachers and children alike, were lost in the blinding storm. The schoolchildren's blizzard lasted for three days and was one of the deadliest ever on the Great Plains.

Even worse than winter storms were the prairie fires that tore across the grasslands in dry autumn weather. T. W. Dean, a neighbor of Solomon Butcher's, had a terrifying brush with one. Early one morning, he woke to find his room as "light as day—the whole heavens seemed to be on fire." As he threw on his clothes, he saw orange flames leaping toward him "at the speed of a race horse."[5] Dean turned two of his horses loose, and they headed toward the river. Jumping onto another horse, he followed. Suddenly a wall of flame twenty feet high shot up in front of him. Spurring his horse madly, he turned back and galloped through thick black smoke to safety. Dean survived with only seconds to spare, although his hair and skin were scorched. His mount lived too, but the loose horses had not been so lucky. One burned to

death. The other, also burned, got stuck in the river's quicksand and could not be pulled out.

Prairie fires were hard to outrun because they raced along on the wings of the wind. A raging fire sent every creature running—or galloping, hopping, flying, slithering—for its life. Whenever possible, the settlers fought back. They banded together to haul barrels of water from the nearest creek. Men, women, and children grabbed shovels and wet sacks and tried to beat down the flames at the edges of an inferno. Farmers plowed firebreaks, strips of bare ground, around their houses for protection. Sometimes they lit a backfire to halt the main one. But some fires, like the one that almost killed T. W. Dean, burned unchecked until they reached a body of water or until it started to rain.

The extreme weather of the plains threw other natural disasters at the settlers too. People wrote to Butcher about dust storms and tornadoes as well as hailstorms that dropped hailstones big enough to kill a cow. And the most discouraging of all was drought. A long drought could turn a field of corn into nothing but a cloud of dust.

In Nebraska about half of the homesteaders who claimed land gave up at some point and moved away. It was easier to obtain a homestead than to keep one, and only the most determined hung on. Those who stayed were stronger, in their way, than prairie fires or blizzards or despair.

"There may be better people somewhere in the world, but I have never met them," wrote one Nebraskan.[6] The pioneers helped each other; their survival often depended on it. If one man had a well, he shared his water. If weather or illness left a family hungry, neighbors brought food and helped with the crops. Strangers could count on shelter in a storm, and any traveler stopping at a little soddy would receive a welcome and a meal. Even if the house were empty, there might still be dinner. "Help yourself,

ATTACK OF THE GRASSHOPPERS

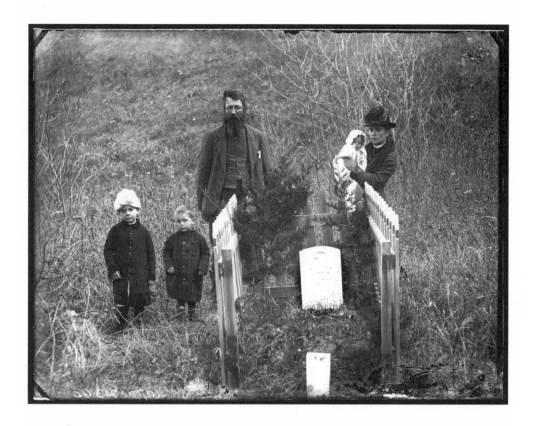

but for God's sake SHUT THE DOOR," read a sign on a Custer County dugout.[7]

In the early years, neighbors were usually separated by miles, and the nearest town could be even farther. Frontier women, especially, were cut off from the outside world. While their men worked in the fields with other men or drove to town for supplies, wives and mothers usually stayed home. They cared for the children and doctored the sick—the closest doctor was often a day's ride away. Women cooked meals in stoves that were also used for heat. In the absence of wood, they gathered whatever fuel they could find on the prairie—hay; cornstalks; cow manure, or "cow chips," as it was called. Frontier women also

The Harvey Andrews family posed at the grave of son Willie. Births, deaths, and often burials took place on the family farm. (NSHS ID. 12871.)

53

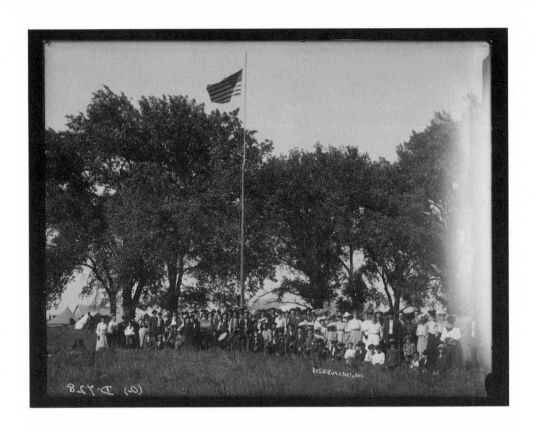

A Fourth of July picnic.
(NSHS ID. 10114.)

sewed clothes, cleaned the house, herded livestock, planted gardens, and more. Weeks, even months, could pass when they had no visitors, only the wind for company. For many, loneliness was worse than storms, worse than snakes. So homesteading families came together as often as they could. And even if they spoke different languages, a spirit of community grew up on the plains.

Solomon Butcher and his camera attended skating parties, picnics, county fairs, and all kinds of celebrations. Solomon himself hosted one of the first Fourth of July parties in the Middle Loup valley. As part of the festivities, he held a contest for the prettiest baby—free tintypes were the winner's prize. Settlers formed choirs and theater groups, went to quilting bees and cornhusking

ATTACK OF THE GRASSHOPPERS

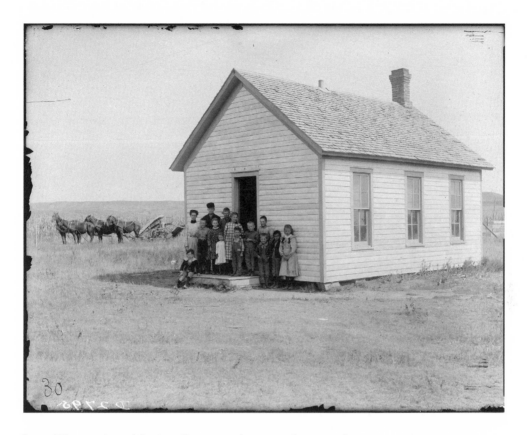

bees. They gathered from miles around to attend square dances. Babies slept, couples whirled and stomped, and the fiddler played all night. Wagons didn't head home until morning.

Students and their teacher in front of a country school. (NSHS ID. 13626.)

One woman wrote, "It is true that we were all poor people in those days and were compelled to endure many hardships, but above it all we certainly were all rich in visions and dreams as to the future."[8] An important part of that future was education. Adults organized debating clubs and literary talks—Shakespeare amid the cornfields! For their children, they built schools. The first ones in Custer County were one-room soddies for students of all ages. The schools, which often doubled as churches or Sunday schools, had dirt floors and plank benches. Blackboards and

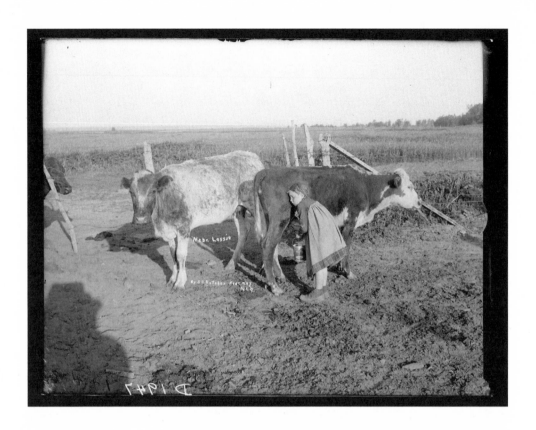

Solomon's niece, Alice Butcher, milking her favorite cow.
(NSHS ID. 16482.)

desks were a luxury. Books were usually a random assortment, collected from the surrounding homes. Teachers were scarce in the early years, and the pioneers could not afford to be too particular. One teacher was only fourteen when she was hired: "If I fail you, you need not pay me," she said.[9] In some places, children had to walk or ride many miles to get to class. When the weather was fine, remembers one man, they "either went to [school] or went a-fishing."[10] Still, Nebraskans managed to achieve a high literacy rate, and as one teacher fondly recalled, "I found in that little, obscure schoolhouse some of the brightest and best boys and girls it was ever my good fortune to meet."[11]

School sessions were short, about two to three months at

ATTACK OF THE GRASSHOPPERS

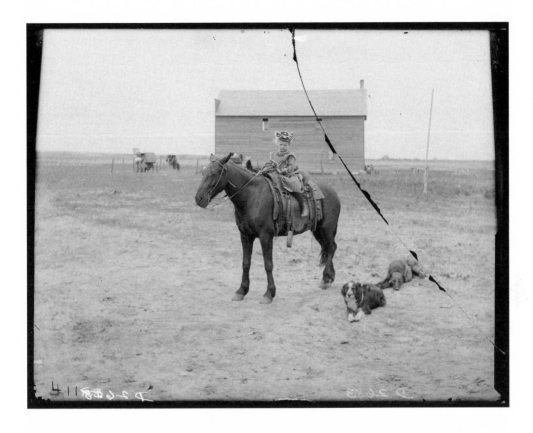

Best friends.
(NSHS ID. 13484.)

a time, because children were needed on the farm. They were taught to do whatever their parents did, and as early as possible. Butcher took pictures of boys and girls herding cattle and helping with the harvest. One of his photographs shows his niece Alice Butcher, eight years old, milking her favorite cow. A boy of her age might be sent out with a rifle to hunt a deer or a jackrabbit for dinner.

Children worked hard and endured all the hardships of pioneer life, but there was also a sweet freedom to life on the prairie, and carefree days when they had the run of the land. They went exploring with their dogs and galloped their ponies through the tall grass. They hunted for birds' nests, caught tadpoles in the

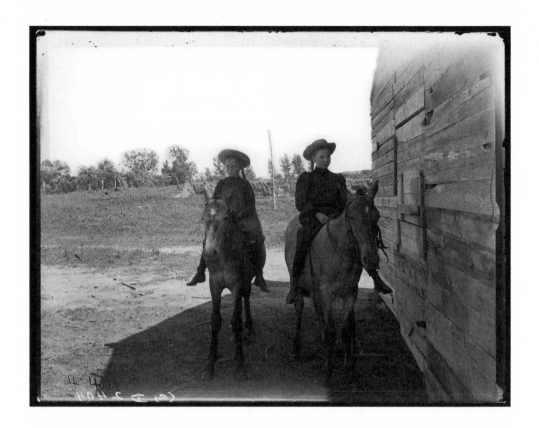

Two girls in braids.
(NSHS ID. 12942)

creeks, picked wild plums and wild cherries. Summer brought brilliant sunlight and warm winds. In autumn the prairie turned tan and brown and gold, and the air was filled with the smell of freshly cut hay. It was a beautiful land. One woman who had come to Custer County in 1884 writes, "One of the vivid recollections of my childhood is of those pioneer days, dewy summer mornings, millions of prairie flowers everywhere, frogs croaking, prairie chickens booming and ducks quacking in that, their own country."[12]

ATTACK OF THE GRASSHOPPERS

*The William Erickson
children, ready to ride.*
(NSHS ID. 14394.)

Desperadoes

S oon after Solomon Butcher had settled in central Nebraska, farmers began to outnumber ranchers. But the ranchers had been there first. Cattlemen had discovered that the grasslands that had fed millions of buffalo were ideal for fattening cattle. From the end of the Civil War until the mid-1880s, cowboys drove bellowing herds up the dusty trail from Texas to graze on the plains of Nebraska and neighboring states. People who lived in the Great Plains established homegrown ranches, too. These were the days of the open range, when land was free for the taking. Custer County, with its miles of natural pasture, was in the heart of cowboy country then. Even in 1880, when the Butcher family came, there were twelve times more cattle than humans. One rancher described this part of Nebraska as "a perfect paradise for cattlemen."[1]

A section of the Brighton Ranch. (NSHS ID. 12335.)

The early ranch houses may have been small soddies, but the cattlemen's domain was enormous. Their cattle foraged over hundreds of miles—all the herds mingling as they grazed. At the spring roundup, cowboys separated their bosses' animals from the crowd and branded the newborn calves before setting them free again. Every fall, cattle were selected for market. They were driven to the nearest cow towns to be shipped by rail to slaughterhouses in Chicago and Omaha, which was fast becoming a major meat supplier to the nation. The Civil War had left the country with a great pent-up demand for beef. Ranchers' expenses were next to nothing. Their profits were high. In 1881 a man named

James Brisbin wrote a book entitled *The Beef Bonanza; or, How to Get Rich on the Plains.*

Cattlemen could get rich, but seldom could cowboys. They were young and footloose, and they signed up for the job because they liked the freedom of life in the saddle. But their work wasn't easy. They slept on the hard ground, put up with bad food, and were out in all kinds of weather. And when there was a storm, they had to handle that most dreaded event—the stampede.

A man named J. D. Haskell wrote a letter describing a night in which he was the only cowboy chasing a panicked herd: "The darkness was intense. A terrible wind drove the rain in sheets. The entire herd jumped to their feet as one steer and started on

a wild stampede before the storm. And oh, such a night!"

The second the cattle started running, Haskell sprang onto his horse. Galloping hard, he kept pace with the herd. "The roar of 4,000 hoofbeats, mingled with the constant crash of thunder, made it a race never to be forgotten. The cattle could only be seen . . . at the flash of the lightning, which was so dazzling as to almost blind [the] eyes."[2]

His horse stumbled but got up and kept going. After more than a mile, the young cowboy was able to turn the lead steer. Gradually, the rest of the herd followed until the cattle were milling in a big circle. At last they came to a stop. Haskell was lucky that night; he surely knew cowboys who had been crushed under stampeding hoofs.

It was no wonder that cowboys got rowdy when they came off the range to deliver their cattle. If they drank their wages at the saloon, anything could happen. They might shoot up the bar or set up target practice in the street. Gunfights broke out between gamblers and even between angry townsfolk and the "boys." On the prairie, they called this "painting the town."

Not all ranchers and cowpokes were men. Butcher photographed cowgirls such as Miss Sadie Austin, the "best known cowgirl in Cherry County." Ready to ride the family ranch, Sadie posed next to her horse, a rifle in one hand and a pistol tucked in her belt. According to her photographer, this no-nonsense cowgirl was also an "accomplished musician."[3]

Solomon wrote about Uncle Swain Finch's wife, Aunt Sarah, who was a rancher in her own right. On her ranch, she was the only woman within forty miles. When the men were away on the roundup, Sarah could be alone for as long as a month at a time. She herded cattle on the home range and threw a lariat like an expert. She was a woman who did whatever was needed, and "a braver one never trod the soil of Nebraska," noted Solomon.[4]

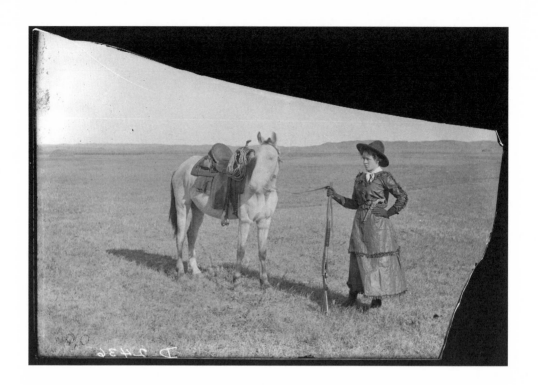

*"Miss Sadie Austin,
a typical Nebraska
cowgirl" and an
"accomplished musician."*
(NSHS ID. 12988.)

Wherever ranchers and farmers went, rustlers were sure to follow. In the 1870s and 1880s, horse and cattle thieves prowled Nebraska. Custer County was established in 1877, in part to control the outlaws—its lonely hills and canyons made perfect hideouts. Some rustlers even dug underground corrals in which to keep their stolen animals. In the words of one settler, the county was "infested with murderers, thieves, desperadoes and cutthroats of all grades and kind."[5] This bloody reputation traveled. A brakeman on the Burlington and Missouri River Railroad shouted to the passengers one day as his train pulled into the station, "You have now crossed the Custer County line; prepare to meet your God."[6]

In the frontier days, there were few jails. Sheriffs and other

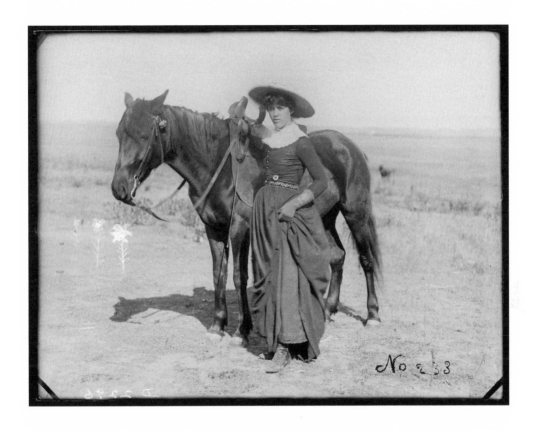

law enforcement officers were also scarce, and those who were there could sometimes be bribed. Frontier justice often filled in the gaps. In some circles, horse thieving was considered worse than murder. Posses of vigilantes carried out lynchings with few questions asked, and innocent men were hanged along with the guilty. Other quarrels were settled at the point of a gun. Even as law-abiding Nebraskans were busy building towns, businesses, farms, and ranches, they were living in the midst of the Wild West.

Men like Judge William Gaslin were elected to establish the rule of law. From 1876 to 1892, the judge served Custer County and his entire district, which included about half the state. He traversed the prairie by horse and buggy, holding court in

Mattie Lucas, in Custer County.
(NSHS ID. 12715.)

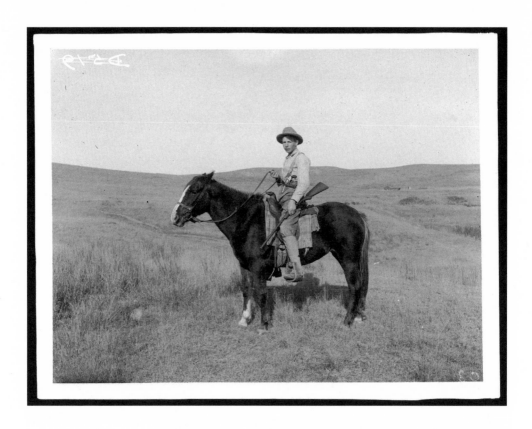

Charley Meeks, cowboy.
(NSHS ID. 12637.)

a "blunt, crisp way" and "without any frills or delays," wrote a man who knew him.[7] In just his first three years in office, Gaslin heard twenty-six murder cases. He was not afraid to make enemies or to hand down stiff sentences, and he succeeded in bringing to justice many of Nebraska's worst desperadoes.

One of the most notorious outlaws in central Nebraska was a man called "Doc" Middleton. In 1875 he had come up from Texas as a cowboy and begun his life of crime in a barroom brawl that ended in murder. With a price on his head, there was no turning back. He formed a gang with the outlaws Kid Wade, Black Bill, Jack Nolan, and others. They stole thousands of ponies from the Sioux reservation and then branched out to stealing horses and

terrorizing citizens everywhere. The men had a hideout with an underground tunnel in Custer County, but they enjoyed more comfortable stays at the local ranches, too. To stay on the gang's good side, ranchers usually hid them from the law. There were some narrow escapes, though. Solomon Butcher wrote a story that describes an unexpected meeting between Doc Middleton and a sheriff. In the story, Butcher refers to the outlaw as Dick Milton, to protect his identity!

> One day [Dick] was at the Olive ranch, when who should walk in but Pat O'Brien. Quick as lightning, Milton was on his feet with a 44 Colt's almost in the face of the astonished sheriff, who, for an instant, thought his time had come, as he looked down the muzzle of the huge weapon that almost tickled his nose.
>
> Milton coolly said: "Are you looking for me, Pat?"
>
> "N-No, sir," gasped Pat.
>
> With an oath the other replies: "Well, Pat, it's an awful good thing that you're not."
>
> With this he made his way to the door, covering the sheriff with his revolver as he backed out, and disappeared. O'Brien remained in the house for a short time chatting, and when he went out found that Milton had taken his horse and left him to go a-foot.[8]

Doc was eventually captured in an ambush and sent to jail for five years. He came out a changed man. Moving to another state, he started a new life as a proper businessman and even became marshal in his new town.

Butcher made two photographs in which he staged an episode from Doc's life. A popular cowboy amusement of the day involved shooting at a man's feet, aiming near enough to make him hop. This was known as "making the tenderfoot dance." One day, the story goes, Doc watched a young cowboy tormenting an old man this way. His sense of fair play offended, Doc grabbed

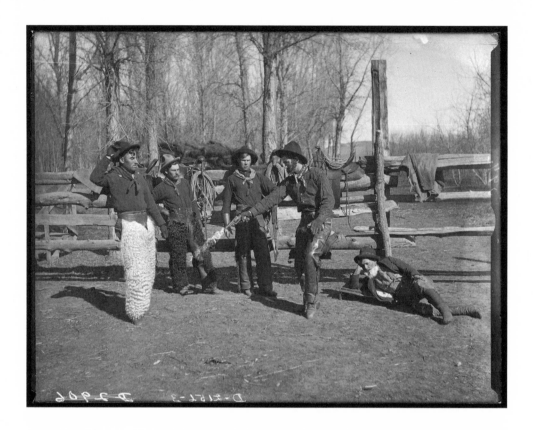

his gun and made the young man dance, to give him "a dose of his own medicine."[9] Butcher entitled both pictures "Cowboy Dancing Lesson."

For years, cattlemen had the run of the Nebraska prairie, as well as most of the range on the Great Plains. "It was thought . . . that this country would never be settled up, but would forever remain a range for cattle," said a Custer County pioneer.[10] Then settlers—"nesters" the ranchers called them—began to claim homesteads and plow up the sod. The settlers hated having their crops trampled by wandering cattle, so they strung barbed wire fences around their fields. Ranchers retaliated by enclosing immense stretches of country that belonged not to them but to the

DESPERADOES

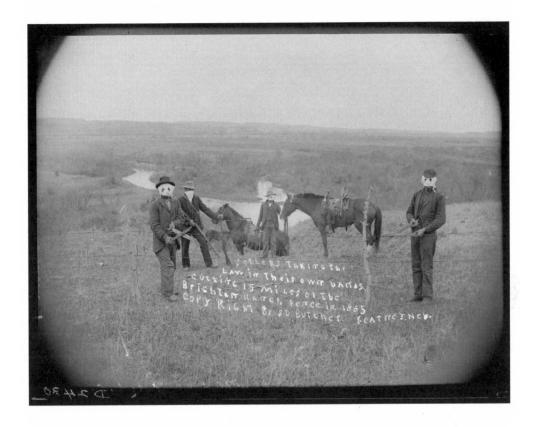

The following caption appears in the photograph:

SETTLERS TAKING THE
LAW IN THEIR OWN HANDS
CUTTING 15 MILES OF THE
Brighton Ranch fence in 1885
COPY RIGHT BY S.D. BUTCHET KEARNEY NEB.

U.S. government. They also had their employees claim phony homesteads all around ranch headquarters to keep the settlers away. Land disputes between farmers and cattlemen became so bitter that they came to be known as the "range wars."

The Brighton Ranch, which sprawled for thousands of acres in Custer's South Loup valley, was one of the largest in central Nebraska. In 1885 its wealthy owner illegally fenced in a huge piece of prairie. The local farmers refused to accept this. They banded together, and in just one night they cut all of Brighton's barbed wire along a fifteen mile stretch. Solomon photographed a reenactment of this deed, complete with white masks like the ones worn by the original wire cutters.

A reenactment of settlers taking the law into their own hands, cutting a barbed wire fence on the Brighton Ranch.
(NSHS ID. 12299.)

The range wars turned violent, as men on both sides tried to push each other off the land. They ransacked, burned, and tore apart each other's property. They stole or killed livestock. "Quit or I'll shoot!" a cowboy threatened two farm boys who were walking behind their plow.[11] Often, threats turned into real shootings, and lynch mobs took the law into their own hands. The cattlemen were fierce, but the settlers were too. Many settlers were tough Civil War veterans, who, in one pioneer's opinion, "held life as cheap and could shoot as straight as the daredevil cowboy."[12]

In 1885 the federal government passed a law forbidding the fencing of public lands. The law was designed to rein in the powerful cattlemen, but by that time, the farmers had mostly won the range wars. There were more farmers than cattlemen on much of the Great Plains, and ranchers were moving farther west, to lands less crowded. A series of hard winters had also forced many ranchers to quit, or at least caused them to keep their cattle from roaming. The golden age of the open range was over.

By 1892 Solomon Butcher had toured the prairie for seven years. He had taken 1,500 photographs and collected the same number of stories, one for each picture. He was close to realizing his dream of a book on pioneer history. Then everything came grinding to a halt.

Sheep in Custer County.
(NSHS ID. 12066.)

Years of Trial, Years of Change

The trouble started in the summer of 1890. It was blistering hot—one day in July the thermometer reached 115 degrees. There was very little rain. Burning winds blasted the Great Plains, the parched earth cracked open, and the corn crop began to wither. Drought settled on the land like a heavy blanket, and in the next few years, it only weighed more heavily. And then in 1894—"that awful year that burned everything to a crisp," said one farmer—there was no crop at all.[1]

Along with the drought, a financial depression was again rocking the nation. In Nebraska, banks failed, stores closed, buildings and even whole towns emptied. Even the grasshoppers returned. Willa Cather, one of Nebraska's—and America's—greatest writers, called this time the "years of trial."[2]

Central Nebraska, including Custer County, was hard hit. During

the 1880s, this part of the state saw the greatest number of new farms. Now, as the drought dragged on, many of these were failing. In some places, farmers had no corn to feed their hogs and were forced to kill the animals to save them from slow starvation. In other places, the people themselves were starving. Thousands of families gave up and left. "In God we trusted, In Nebraska we busted," was their slogan.[3] As with the grasshopper invasions of the 1870s, food and supplies were sent from all over America. But it was not enough. Lizzie Chrisman remembered the drought years as the hardest period of her life.

Solomon Butcher struggled along with everyone else. He went to work on his father's farm, where the family coaxed up just enough of a crop to put food on the table. The rest of their needs they filled by bartering. From 1892 to 1899, Butcher sold no pictures at all. No one in Nebraska had the money to spend on luxuries like photographs.

There had always been periods of drought on the plains. But the drought of the 1890s shocked the more recent immigrants. The previous decade had been rainy enough to produce bountiful harvests. Newcomers expected these to continue because they had heard that "rainfall follows the plow."[4] This boldly advertised theory held that plowed soil absorbs more moisture than unplowed, and that this excess moisture would evaporate and come back as increased rain. "Rainfall follows the plow" was an idea that helped populate the dry western plains. But it wasn't true.

As crops dried up and crumbled around them, Nebraskans put new words to an old tune:

Sweet Nebraska Land

Nebraska land, Nebraska land,
As on thy desert soil I stand
And look away across the plains,
I wonder why it never rains.

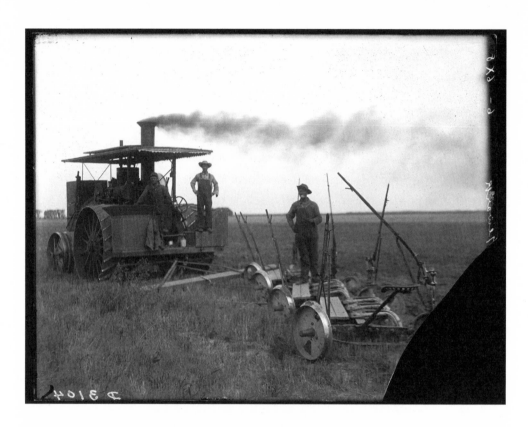

A steam tractor pulling a plow. (NSHS ID. 10017.)

There is no wheat, there is no oats,
Not even corn to feed our shoats.
Our chickens are so thin and poor,
They come and peck crumbs off the floor.

Our horses are of bronco breed;
They have nothing on which to feed.
We do not live, we only stay;
We're all too poor to get away.

Nebraska land, Nebraska land,
As on thy desert soil I stand
And look away across the plains,
I wonder why it never rains.[5]

Even before the drought, plains farmers had been struggling. In the rainy 1880s, they took out loans and mortgages to buy the latest farm equipment—steam-powered machines were replacing the old horse-drawn models. But the new technology proved so efficient that it resulted in an oversupply of crops. The bigger the harvest, the lower the crop prices dipped; and farmers took home less and less money.

The railroad companies added to the problem. They had lured settlers to the prairie with promises of dazzling fortunes to be made. Yet they soon set their freight rates so high that farmers couldn't make a profit when they sent their goods to faraway markets. Often the cost of shipping a bushel of wheat was the

Stacking hay on a ranch in Buffalo County, Nebraska. (NSHS ID. 12705.)

75

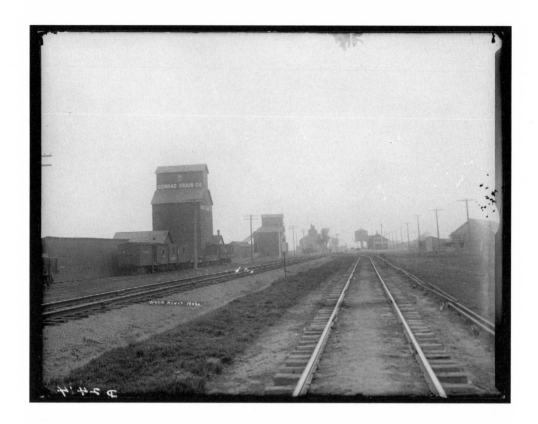

*Grain elevators by
the train tracks.*
(NSHS ID. 12957.)

same as the price of the wheat itself. Big loans to pay back, and small profits. Even when fields were bursting with green corn and golden wheat, farmers could not pull themselves out of debt.

They believed that both political parties, Democrat and Republican, had been bribed by the railroads to ignore their needs. So they formed the Farmers' Alliance, an organization that grew to include state and local chapters throughout the Great Plains. The Nebraska chapter soon became the largest in the country, attracting many thousands of work-weary members, eager to make their voices heard. In the drought-smothered summer of 1890, the Nebraska Alliance held a convention in Lincoln. "We farmers raised no crops, so we'll just raise hell!" the alliance men

*A Populist convention
in Nebraska.*
(NSHS ID. 10007.)

cried.[6] Then they launched a new and independent political par-
ty—the People's Party, or the Populists. Traditional politicians
looked down on the Populists as "hogs in the parlor" and "hay-
seeds."[7] But the movement spread quickly throughout the plains
and other farming regions in the country. It was a grassroots
farmers' revolt.

Nebraska's Populists led a fiery campaign that summer, with
speeches as scorching as the heat. They denounced Nebraska's
two main railroads, the Union Pacific and the Burlington and
Missouri River, as robbers. They called the powerful politicians
corrupt. They pressed for reforms in government, such as adop-
tion of the secret ballot and for an eight-hour workday for urban

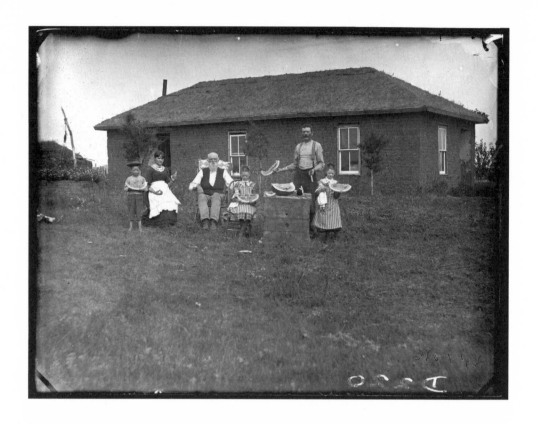

Omer Kem (standing), the sodbuster congressman. (NSHS ID. 10026.)

workers. And because there was a serious shortage of dollars in the money supply, they pushed for the free coinage of silver. With silver in circulation, Populists believed that farmers could more easily pay their debts.

The election of 1890 was a smashing victory for the "hayseeds." The Populists gained control of the Nebraska legislature. They also won two of the state's three seats in the U.S. Congress. One of the new Populist congressmen was Custer County's Omer Kem—the only Nebraskan ever to be sent to the House of Representatives while living in a sod house. Kem, who had posed for a Butcher photograph, was proud to be a sodbuster. Clodhopper Kem was his campaign name.[8]

But the Populists' hold on power soon began to slip. In 1894 they joined a fusion coalition with Nebraska's Democrats, whose leader was a young lawyer named William Jennings Bryan. Bryan shared many of the Populists' views. An electrifying and eloquent speaker, he stood up for the poor and the working class against the might of big business. The fusionists helped elect Populist governors for the rest of the 1890s. And Bryan, known across America as the Great Commoner, would run for president of the United States three times—in 1896, 1900, and 1908—but without success.[9]

Solomon Butcher too took part in Populist politics. In 1896 he was elected justice of the peace and clerk of the election for the little town of West Union. By this time, though, the movement was fading. The rains had come back to the plains, crop and livestock prices were rising, and the financial depression had lifted. Farmers were not as desperate as they had been before. The Populist Party would disband completely in 1908. But it would have lasting influence in Nebraska. Much of its platform would be adopted by Democrat and Republican administrations alike. Farmers would finally see railroad reform and other welcome reforms enacted into law. Populist thought swept through the entire nation—ideas about fairness and economic opportunity for all citizens changed American politics forever.

Nebraska in the 1890s wasn't the same as it was when the Butchers' covered wagons had first rolled onto the prairie. Sod farmhouses were rapidly being replaced by tidy new frame ones. The flow of immigrants had slowed, and Nebraska's population numbers would remain roughly the same in the coming decades. Although the Sandhills and western parts of the state were still largely frontier, most other areas of Nebraska were well settled. In 1891 two land laws—Preemption and Timber Culture—were repealed because they were no longer needed.

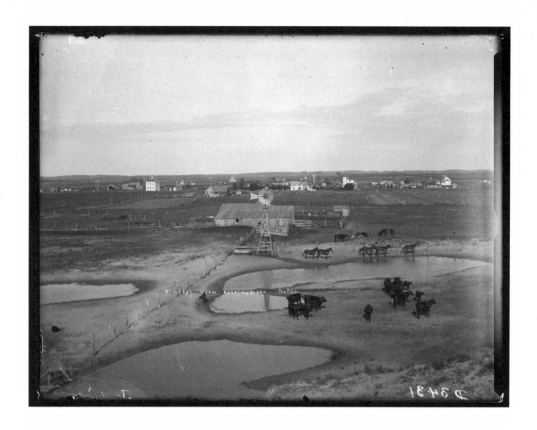

Bird's-eye view of Anselmo, a small town on the prairie.
(NSHS ID. 14469.)

The sod-house era, which had lasted about thirty years, was coming to a close.

Especially for townspeople, this was easy to see. Omaha was now a major metropolis and a national center for the grain and meatpacking industries. Lincoln, in addition to being the state capital, was home to the state university and many other cultural institutions.

Small towns that had appeared on the prairie in the 1870s and 1880s were no longer just brave little clusters of tents and shacks. They had turned into busy, modern towns, even cities. In 1883, when Lizzie Chrisman first saw the town of Broken Bow, it was only a huddle of "twelve sod houses and one frame store."[10] But

right away, it acquired a newspaper. And although lumber had to be hauled by horse and wagon from towns on the Platte, Broken Bow was soon full of frame buildings—a general store, a bank, a hotel, a butcher shop, and more. After the railroad came through, wooden construction gave way to solid brick and imposing stone.

The town of Aynsley, established in 1886 and also in Custer County, grew even faster. A newspaper editor wrote to Solomon Butcher about his stay in Aynsley's first hotel. Because it consisted of only one room, some guests had to sleep on the dining table. In the morning, the hotel clerk would shout, "Time to roll off them tables; the girls want to set the tables for breakfast." About a month later, Aynsley had changed from "a brown prairie to a busy village," with twenty buildings underway.[11] By the 1890s it had become a thriving town with many private houses and every kind of store—all lit by electricity.

As they neared the twentieth century, Nebraska's farmers made changes too. They used improved machinery and planted hardier crops, such as winter wheat. The drought had taught them that they could not farm on the semiarid plains by the same methods that worked in the rainier climate of the East. They would have to find a different way. As one man said, "The time has come when the farmer must mix brains with his soil or fall to the rear."[12] Nebraskans decided to try techniques of dryland farming. These techniques were newly developed especially for their land—a land plagued by low rainfall but blessed with fertile soil and the nation's largest supply of underground water. Many farmers now plowed deeper, sowed seeds fewer and farther apart, rotated crops, and let fields rest for a season or two between plantings. The state also started irrigation projects, which would water more acres every year. Experiments in dryland farming were beginning to work.

By 1899 Solomon Butcher's fortunes had also improved. Higher

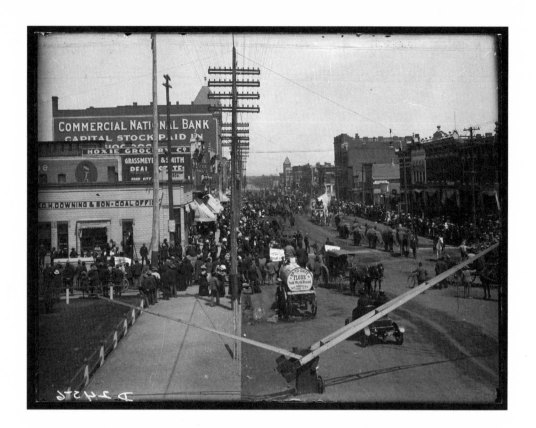

Circus day in Kearney, Nebraska, circa 1900. (NSHS ID. 13008.)

crop prices had allowed him to move his family into a new frame house on the north side of the Middle Loup River. "I had secured a nice little home and was nearly out of debt, and was again about to take up the history scheme where I had dropped it in 1892," he wrote.[13] He was in a hurry to finish, after all, because in most parts of Nebraska, pioneer days were already a memory.

Early on the morning of March 12, Solomon's son Lynn, now sixteen, lit the breakfast fire in the stove. A short time later, Solomon noticed a flame flickering where the stovepipe passed through the roof. Lynn ran to get a ladder and some water to smother it, but Solomon took charge and scrambled up the ladder himself.

In his haste, he fell off and plunged to the ground, unconscious. While his family hovered over him, the flames became a roaring fire. The new house burned to the ground. "We saw our home and its contents go up in smoke, with no insurance and all our seven years' work."[14] Almost everything the Butchers owned was lost. Including hundreds of photographic prints and all 1,500 of Solomon's pioneer biographies. The 1,500 glass-plate negatives, however, had been stored separately in a grain shed. They were all that was left of Solomon's travels on the prairie.

Pioneer History of Custer County

He was forty-three when his house burned down, when seven years' worth of pioneer tales turned into a heap of ashes. And even though he was broke—again—he quickly resumed work on the pioneer history. As Lynn Butcher later wrote, "My father had what he called 'Western push and energy' and there was never any question [about] starting all over again."[1] Within weeks of the fire, Solomon was taking more orders for his book. He began collecting new stories. He rewrote many from memory. And he arranged for George Mair, a talented newspaper editor, to help with the writing and editing. Solomon's "Western push" drove him to reach his goal. Just eighteen months after the fire, he had gathered another batch of stories for his book and selected the photographs to illustrate it. Fifteen years after he had first thought of it, his history project was finally finished.

But it took money to have the book printed, and Solomon had none. He confided in Uncle Swain Finch, and Finch decided to come to the rescue. "Butch," the old man said, "you have worked faithfully and deserve success, and if the people of Custer County want a history, by George, they shall have it."[2] Finch agreed to raise the money to pay for production of Butcher's book, and he put an ad in a newspaper, the *Custer County Chief*, announcing his decision: "To whom it may concern—I hereby agree to fill all bonafied [sic] orders for Butcher's pioneer history that is given by May 1st, 1901, E. S. Finch."[3] Uncle Swain had such a solid reputation in Nebraska that orders soon came pouring in.

Pioneer History of Custer County, and Short Sketches of Early Days in Nebraska was published in 1901. It is more than four hundred pages long and contains eighty short biographies and two hundred of Butcher's photos. Butcher dedicated the book to "the Pioneers of Custer County, that noble band of men and women who blazed a pathway into the wilderness."[4] And he included a chapter about his own adventures, entitled "An Old Settler's Story." In it, the "old settler" describes how he got the idea for the book itself and his long struggle to see it into print:

> I told my scheme to everyone I met. I talked it constantly. I have talked it nearly fifteen years, and if God spares me I intend to keep talking it until Custer County is full of books. And as hundreds are already sold, I think I see in the future a partial realization of my dreams. After fifteen years of such a checkered career as few men have experienced, I have still been able to wrench success from defeat. . . . How well I have succeeded I will leave the reader to judge after he has read this book to the last page and looked at the last picture.[5]

The first edition of *Pioneer History*—one thousand copies—sold out right away. Butcher and Finch immediately ordered a second printing. Now the photographer had the pleasant job of

The Sandhills in Custer County.
(NSHS ID. 10217.)

delivering books to subscribers throughout Nebraska, on farms and ranches, in small towns, and in cities as far away as Omaha and Lincoln. He also stopped at newspaper offices along the way to show sample pages of his work. After the long spell of drought and the disastrous house fire, Butcher was on the road again.

Even though his book had been published, his camera work was far from over. In the new century, he would steer his photo outfit farther than ever. In 1900, before *Pioneer History* was finished, Butcher took a seven-week trip through Nebraska's Sandhills. The Sandhills begin in the northwest corner of Custer County and extend in a giant oval—for eighteen thousand square miles—through the northwestern part of the state. A land of rolling sand

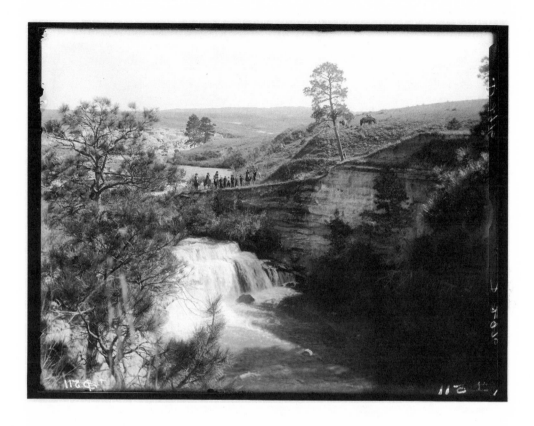

dunes molded by the wind and covered with grasses, the region is a world apart, lonesome and beautiful. Once the Sandhills had been home to the buffalo. In the early 1880s, cattlemen discovered that this stretch of country, with its many lakes and sheltering hills, is one of the best grazing areas in the West.

Solomon spent most of his Sandhills trip up north, exploring Cherry County, the largest county in Nebraska. There he visited sheep and cattle ranches, taking pictures and jotting down facts. He noted names of ranchers, numbers of livestock, tons of hay, and acres of land—one ranch alone maintained seventy-five miles of fence. Butcher toured the little towns. And even though the Sandhills were among the last places in Nebraska to be settled,

Snake River Falls, Cherry County, Nebraska.
(NSHS ID. 10047.)

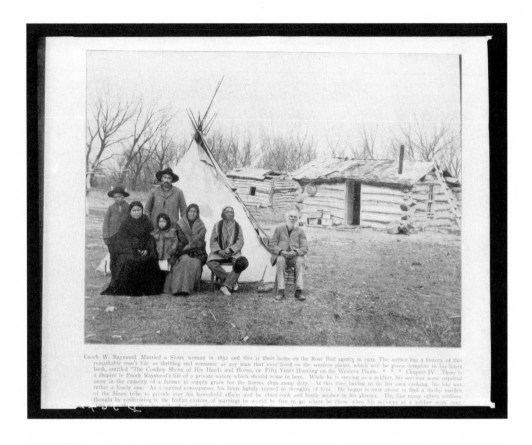

Enoch W. Raymond. Married a Sioux woman in 1852 and this is their home on the Rose Bud agency in 1902. The author has a history of this remarkable man's life, as thrilling and romantic as any man that ever lived on the western plains, which will be given complete in his latest book, entitled "The Cowboy Shorn of His Hoofs and Horns, or Fifty Years Hustling on the Western Plains. * * * Chapter IV. There is a chapter in Enoch Raymond's life of a private nature which should come in here. While he is serving as a soldier, his services were required more in the capacity of a farmer to supply grain for the horses than camp duty. At this time having to do his own cooking, his life was rather a lonely one. As a natural consequence his heart lightly turned to thoughts of love. He began to cast about to find a dusky maiden of the Sioux tribe, to preside over his household affairs and be chief cook and bottle washer in his absence. He, like many others soldiers, thought by conforming to the Indian custom of marriage he would be free to go where he chose when his services as a soldier were over

At the Rosebud Indian Reservation, South Dakota.

(NSHS ID. 12691)

he noticed that the twentieth century was coming there too. Telephone lines were beginning to crisscross the vast rangeland.

Before returning home, he detoured to the rugged country of the Niobrara and Snake rivers, where he spent time investigating the old hideouts of horse and cattle rustlers and other outlaws. He also drove his picture wagon up to South Dakota, to photograph the American Indians living on the Pine Ridge Reservation. In middle age, Butcher was at last making a living, although a very modest one, doing what he loved. And it was as if he was making up for lost time.

Pioneer History had sold so well that Butcher and Uncle Swain

planned two more such books, one each for the pioneers of neighboring Dawson and Buffalo counties. In 1902 the Butchers moved south from Custer County to the town of Kearny, in Buffalo County, so Solomon could be near the subjects for his next book. In Kearny he opened a new photography studio. Lynn, now nineteen, was his partner. Once again, Solomon hitched up his wagon and took his camera on a ramble—through Nebraska, Wyoming, Utah, Colorado, and more. He mailed his glass negatives home, where Lynn and a staff of women developed them into prints to be sent back to the customers. The father-and-son team also ran a postcard business, selling postcard photographs—a batch of one hundred for $3.00—of towns and scenery throughout the Great Plains. The Butchers would ultimately produce about 2.5 million of these.

The whirlwind of activity continued. In 1904 Butcher published another book, a short one with a long title: *Sod Houses; or, The Development of the Great American Plains: A Pictorial History of the Men and Means That Have Conquered This Wonderful Country.* He brought it to the St. Louis World's Fair, both to sell it and to entice people to buy land in Nebraska. And for the rest of the decade, he took hundreds more pictures.

Frontier days were past, but Solomon still had big plans. He was keen on recording the stunning changes that had come to the prairie—changes made possible by the powerful determination of the sodbusters. And because he kept his photographic records up-to-date, his collection contains many before-and-after shots.

Farmers and ranchers and townspeople who made it through the 1880s and 1890s had made it through snow, fire, drought, and famine. In the 1900s, as Willa Cather wrote, they "came into their reward."[6] There were many success stories. A farmer who had had a little soddy, perched alone on the prairie, now lived in a large Victorian house, with gingerbread-carved balconies and

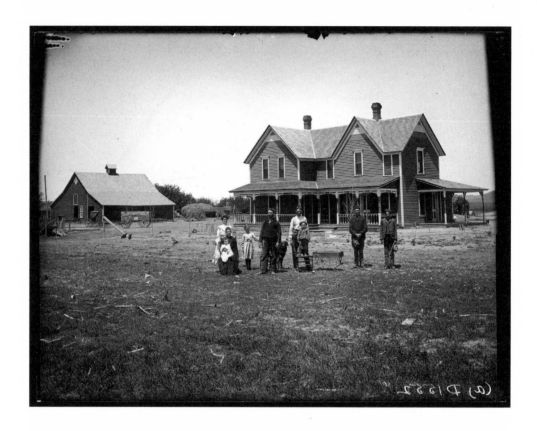

John Downey and
family, in 1904.
As pioneers, they had
started out with $12.00
and two mules.
(NSHS ID. 10923.)

turrets and a comfortable porch where he could sit and look out over his fields. A rancher who had come to Nebraska with $12.00 and two mules now owned thousands of acres and herds of cattle, horses, and hogs.

More and more towns were acquiring telephone lines, streetlights, and public water systems. Even the smallest were linked by rail. And in the early 1900s, the automobile came to Nebraska. For a while, the loud, sputtering machines gave right-of-way to horse-and-buggy outfits. But within a decade or so, livery stables and blacksmith shops would be outnumbered by gas stations and auto dealers.

Even the land looked different; the plains were not quite so

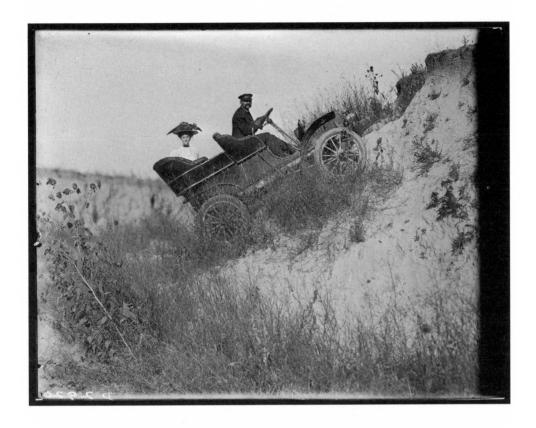

Dr. F. Kerby's new car, 1911. (NSHS ID. 13243.)

treeless anymore. Since 1872, when a prominent political leader named J. Sterling Morton had founded Arbor Day, Nebraskans had planted hundreds of millions of trees. There were cherry and apple orchards and groves of shade trees in the countryside. In the towns, there were tree-lined streets.

Only fifty years earlier—not even the span of a full lifetime—Nebraska had been the unknown, part of the Great American Desert. Many an old pioneer looked back on the past as if it had been a dream.

The cost of printing *Pioneer History* had used up any profits that Butcher and Finch might have seen. Butcher's photography studio had never made much money, either, and although he had

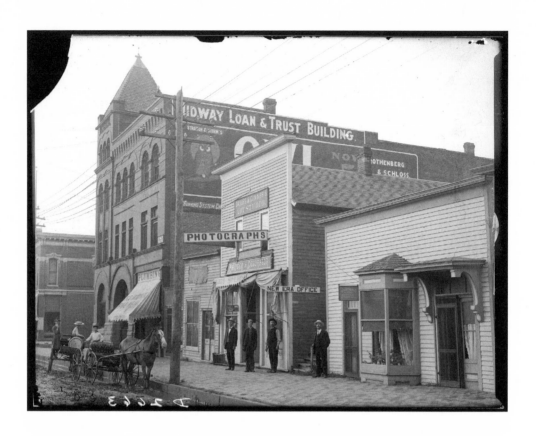

taken many pictures for books on Dawson and Buffalo counties, those plans had fizzled. In 1911 Solomon was fifty-five years old, bald, and stout, and he had not saved enough money for his old age. Leaving Lynn in charge of the Kearny studio, he took a job with a real-estate firm called the Standard Land Company. As a real-estate agent, Solomon sold land in the Rio Grande valley in Texas and arranged trips to the area to attract buyers. He hoped to be able to retire there himself one day. But if he left Nebraska, what would he do with the thousands of glass-plate negatives that he had accumulated in his work? So far, he had carted them along on all his moves, but they were too numerous and too heavy to take all the way to Texas.

He decided to offer his collection of negatives and prints for sale to the Nebraska State Historical Society, in Lincoln, where it could make an important contribution to the history of the pioneer era. He wrote to Clarence S. Paine, secretary of the historical society, and to Addison E. Sheldon, head of a society department called the Legislative Reference Bureau.

In a letter to Sheldon, Butcher described the difficulty of storing and moving the negatives: "Here is where my wife had her patience tried many times, as these boxes of Negatives took up the greatest part of one room and they had to be shifted from one place to another many times." But they were also his family's treasure: "They have always been considered by both of us as something that should be preserved no difference how much inconvenience it made us in doing so."[7]

Clarence Paine was not interested. Addison Sheldon—former Populist, congressman, and newspaperman—definitely was. While Butcher and he were exchanging letters, Sheldon's department broke off from the historical society and became part of the University of Nebraska. No matter. Sheldon believed in the importance of Butcher's photographs and pushed hard for their sale to the historical society. Butcher urged him on: "Now is the time to buy me cheap, when I need the money so badly."[8] On November 29, 1911, Butcher signed a contract. For almost four thousand negatives and prints, he would receive $1,000, including an immediate $100 down payment from Sheldon himself.

Now Sheldon had to convince the state legislature to agree to the deal. Even before the politicians did so, Butcher sent his negatives to Sheldon. The photographer was already planning how to spend his money. For once, he would be able to pay all his debts and still have funds left over.

At that time, the Nebraska legislature met only every other year, so Butcher had to wait until 1913 for the vote. The House

of Representatives approved the full amount of $1,000. But the Senate, probably led by Clarence Paine, agreed to pay only $500. Sheldon persuaded the senators to raise their offer to $600. By this time, Butcher was desperate for money. He sold his collection to the Nebraska State Historical Society for $600 and even had to return Sheldon's advance.

Butcher was bitterly disappointed. He had longed for his photographs to be appreciated, rather than bargained over. A couple of years after the sale, when he had decided not to move to Texas after all, he wrote to Sheldon, "My collection was worth $5,000.00 to the state, and if I had the collection now that I am going to stay in Nebraska they couldent [sic] buy them at any reasonable price."[9]

Sweet Nebraska Land

One newspaper editor who had talked with Butcher about his history project wrote that many people had looked at the venture merely as a "fantastic dream." But Butcher had "just labored on, holding steady and true as the needle to the pole."[1] And he had created something no other photographer of his time had done. Now, after the disappointing sale of his whole collection, much of the shine had worn off the dream. In another letter to Sheldon, Butcher wrote, "I have always thought that man Paine done me a very skurvey [sic] trick when he beat me out of $400 on my collection of early day negatives."[2] He began to spend less time on photography and more on selling real estate.

In 1915 he left the Kearney photo studio in the hands of his employees and moved back to Custer County, this time to bustling

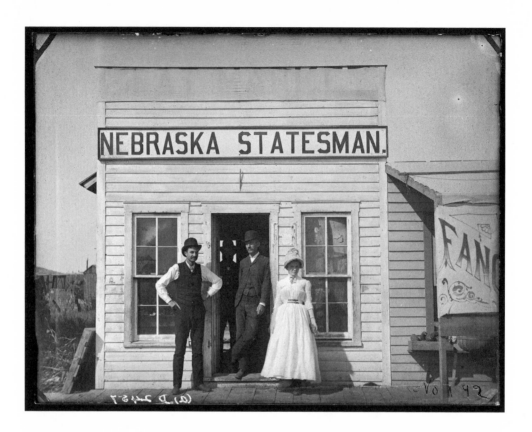

A newspaper office in Broken Bow, Custer County.
(NSHS ID. 13010.)

Broken Bow. There, on December 29, Lillie Butcher died. She was fifty-seven years old and had been sick for a long time. Solomon was alone now, without the companion who had been with him since pioneer days, and his future must have seemed bleak.

Addison Sheldon asked him to come to the Nebraska State Historical Society to help organize the collection. So in January and February of 1916, right after Lillie's death, Solomon went to work in Lincoln. He cataloged his negatives and arranged them in an easy-to-find order. He added new information about many of the photos—putting more names to faces and places, recording background facts and interesting anecdotes. That year, too, his photographs were displayed at the Buffalo County Fair.

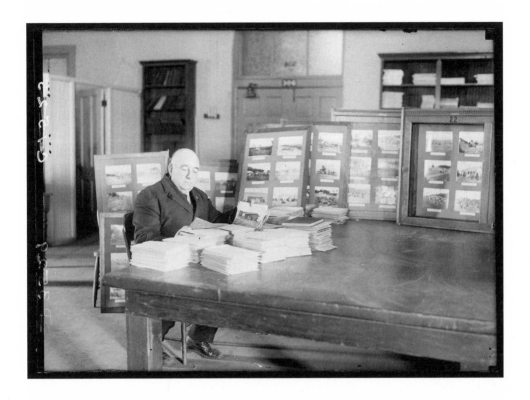

On January 24, 1917, Solomon remarried. His second wife, Laura Brachear Nation, was a widow from Kansas, with a son and daughter from her first marriage. Even though newly married, Solomon was still traveling much of the time, but for his work as a real-estate agent, not as a photographer.

Since 1914, World War I had been tearing up Europe. The Allied forces—Great Britain, France, and Russia—were battling the Central powers of Germany, Austria-Hungary, and Turkey. In 1917 the United States entered the war on the side of the Allies. Lynn Butcher joined the Nebraska National Guard and went off to war. Solomon held on to the studio for a while longer, but with Lynn gone, he decided to sell it to an employee. For the first time in thirty-five years, Solomon was without a photo gallery.

Butcher organizing his photographs at the Nebraska State Historical Society. (NSHS ID. 14562.)

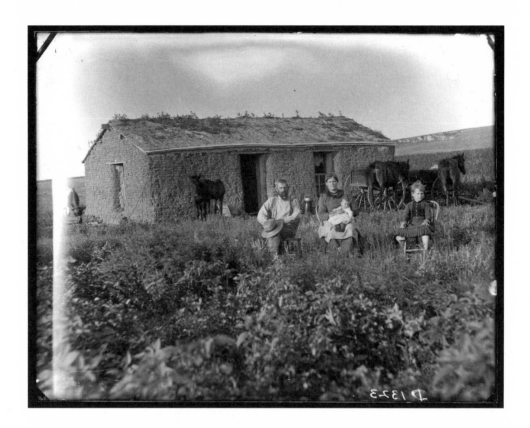

Jules Haumont and his family in the early days. (NSHS ID. 10939.)

Lynn would one day say, "My father was one of the most optimistic persons I ever knew."[3] At sixty-one, Solomon had not given up trying to find a way to make his fortune. He invented a device that he called the Radio Magnetic Oil Finder, the purpose of which was to detect pools of oil underground. He published a brochure full of enthusiastic comments on its effectiveness, but the oil finder did not make him wealthy.

He still believed that he could "wrench success from defeat."[4] He briefly considered taking a photographic tour of Central America and showing travel slides on his return. Then in 1924 he came up with another new product, another surefire way to strike it rich. The product was a cure-all potion that he called Butcher's

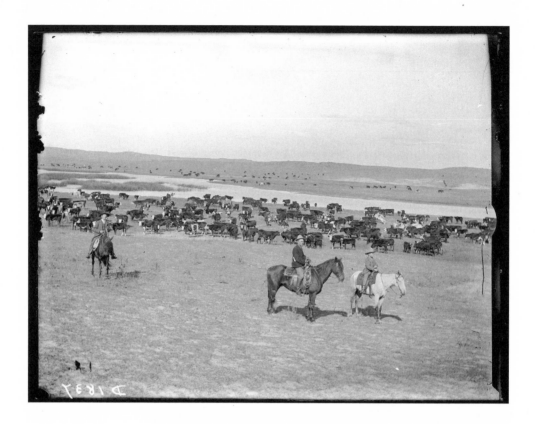

*The Lee Brothers'
Ranch in Cherry
County, Nebraska.*
(NSHS ID. 12092.)

Wonder of the Age, and it was probably inspired by the miracle cures he had sold when he was young. His granddaughter called it "our Great Family Medicine." She described it as "dark brown in color, bitter tasting and smell[ing] the same way."[5] Solomon's relatives gargled with it when they had sore throats and rubbed it on their bodies to ease their aches and pains. He published an advertisement: "S. D. Butcher's 'Wonder of the Age' drives pain and disease from the human body, giving 'Ginger' and 'Pep' to the ailing one, having complete control of all stomach and bowel troubles, healing piles, no difference of how long standing, as if by 'Magic.'"[6] The Wonder sold for $1.50 a bottle, and like the Radio Magnetic Oil Finder, it did not make its inventor rich.

After almost fifty years, Butcher perhaps felt that he had given his beloved Nebraska all he could. In 1926 he and Laura left the state behind and moved to Greeley, Colorado, to live near his daughter Madge. Solomon had been suffering from a kidney disease, and on March 18, 1927, he died. He was seventy-one years old. He was buried back in Custer County, next to Lillie, near the first homesteads that he and his father had claimed on the windswept prairie.

A pioneer named Jules Haumont looked back on his own youth in Nebraska and wrote:

> We came here to this beautiful country, in those early days, young, strong, healthy, filled with hope, energy and ambition. Poor, it is true. Oh! How poor in worldly goods, but rich beyond dreams, in everything that makes life worthwhile. I do not know how large a bank account some of the old settlers may have today, I do not care, they will never be as rich as I felt when I first settled on my homestead. I remember the time I did not have the money to buy a postage stamp. I remember the hard winter, the drought of 1894. The many obstacles to overcome. We came to win the battle, and we did.[7]

This is the spirit that Solomon D. Butcher captured in his photographs. He had that spirit too, and he accomplished what he had set out to do—to tell the story in words and pictures of the generation that settled the Great Plains. Each one of his photographs is arranged to show, not just the pioneers themselves, but their entire way of life—how they worked, what they built, what they loved. Wandering the prairie with his camera, Solomon was a memory keeper.

The history-loving photographer died believing that he had failed, that few would ever value his life's work. He was wrong. As the years passed, people began to pay attention, and now

Butcher's photographs can be found on websites and in films, magazines, exhibits, and history books everywhere. His record of a unique moment in the nation's past has claimed a permanent place in the American imagination. Yet Butcher might have dreamed that this would happen. Like most pioneers, he had a steadfast faith in a better day. "It did not rain all the time," he once wrote, "and when the sun came out and seemed to smile on us, the flowers bloomed with more beauty and all nature seemed to rejoice. Not being of a melancholy disposition, I had to rejoice also."[8]

Where to Find Solomon Butcher's Photographs

The Butcher Collection of glass-plate negatives is at the Nebraska State Historical Society, in Lincoln, Nebraska. Over three thousand of these images, including those reproduced in this book, can also be seen online at the "Prairie Settlement" website. There they form a part of the American Memory Project of the Library of Congress.

The number accompanying the caption for each photo is a digital ID number assigned by the Nebraska State Historical Society and is also used by the "Prairie Settlement" website. I've included six photographs that were not taken by Solomon Butcher; these images have been assigned RG or SFN numbers by the Nebraska State Historical Society.

Notes

Introduction

1. Butcher, *Pioneer History of Custer County*, 145.
2. Butcher, *Pioneer History of Custer County*, 145.
3. Butcher, *Pioneer History of Custer County*, 153.
4. Butcher, *Pioneer History of Custer County*, 153.

The Great American Desert

1. Olson, *History of Nebraska*, 3.
2. Olson, *History of Nebraska*, 3.
3. Luebke, *Nebraska*, 23.
4. Luebke, *Nebraska*, 2.
5. Luebke, *Nebraska*, 7.
6. Dick, *Sod-House Frontier, 1854–1890*, 5.
7. Dick, *Sod-House Frontier, 1854–1890*, 5.
8. Dick, *Sod-House Frontier, 1854–1890*, 52 and 48.

9. Olson, *History of Nebraska*, 94.

10. Daughters of the American Revolution, Nebraska, *Collection of Nebraska Pioneer Reminiscences*, 107.

Solomon Butcher, Sodbuster

1. Mattie V. Oblinger to George W. Thomas, Grizzie B. Thomas, and Wheeler Thomas Family, June 16, 1873, no. RG1346.AM.S01.1109, Oblinger, Uriah Wesley, 1842–1901, Nebraska State Historical Society, Lincoln. Transcript available online at *Prairie Settlement: Nebraska Photographs and Family Letters, 1862–1912*, American Memory, Library of Congress, http://memory.loc.gov/cgi-bin/query/ r?ammem/psbib:@field(DOCID+l109).

2. Dick, *Sod-House Frontier, 1854–1890*, 197.

3. Butcher, *Pioneer History of Custer County*, 145.

4. Butcher, *Pioneer History of Custer County*, 145.

5. Butcher, *Pioneer History of Custer County*, 145.

6. Butcher, *Pioneer History of Custer County*, 145.

7. Welsch, *Sod Walls*, 31.

8. Butcher, *Pioneer History of Custer County*, 145.

9. Creigh, *Nebraska*, 90.

10. Butcher, *Pioneer History of Custer County*, 145.

11. Butcher, *Pioneer History of Custer County*, 147.

12. Butcher, *Pioneer History of Custer County*, 147.

13. Butcher, *Pioneer History of Custer County*, 66.

14. Butcher, *Pioneer History of Custer County*, 150.

15. Butcher, *Pioneer History of Custer County*, 149.

16. Butcher, *Pioneer History of Custer County*, 150.

"Eureka!"

1. Butcher, *Pioneer History of Custer County*, 150.

2. Butcher, *Pioneer History of Custer County*, 151.

3. Butcher, *Pioneer History of Custer County*, 151.

4. Butcher, *Pioneer History of Custer County*, 151.

5. Butcher, *Pioneer History of Custer County*, 153.

6. Butcher, *Pioneer History of Custer County*, 153.

7. Butcher, *Pioneer History of Custer County*, 154.

8. Butcher, *Pioneer History of Custer County*, 153.

9. Chrisman, "Sod House Photographs of Solomon D. Butcher," 28–31.

10. Purcell, *Pioneer Stories of Custer County, Nebraska*, 9.

11. Butcher, *Pioneer History of Custer County*, 67–68.

12. Butcher, *Pioneer History of Custer County*, 76.

13. Welsch, *Sod Walls*, 48.

14. Welsch, *Treasury of Nebraska Pioneer Folklore*, 47.

15. Ward, *West*, 333.

16. Solomon Butcher's 1916 annotations, Solomon D. Butcher Papers, State Archives, Nebraska State Historical Society, Lincoln.

Attack of the Grasshoppers

1. Butcher, *Pioneer History of Custer County*, preface.

2. Butcher, *Pioneer History of Custer County*, 41.

3. Olson, *History of Nebraska*, 175.

4. Purcell, *Pioneer Stories of Custer County, Nebraska*, 30.

5. Butcher, *Pioneer History of Custer County*, 248–49.

6. Purcell, *Pioneer Stories of Custer County, Nebraska*, 34.

7. Butcher, *Pioneer History of Custer County*, 375.

8. Purcell, *Pioneer Stories of Custer County, Nebraska*, 12.

9. Purcell, *Pioneer Stories of Custer County, Nebraska*, 107.

10. Butcher, *Pioneer History of Custer County*, 367.

11. Daughters of the American Revolution, Nebraska, *Collection of Nebraska Pioneer Reminiscences*, 25.

12. Purcell, *Pioneer Stories of Custer County, Nebraska*, 86

Desperadoes

1. Butcher, *Pioneer History of Custer County*, 8.

2. Butcher, *Pioneer History of Custer County*, 25–26.

3. Solomon Butcher's 1916 annotations, Solomon D. Butcher Papers, State Archives, Nebraska State Historical Society, Lincoln.

4. Butcher, *Pioneer History of Custer County*, 42.

5. Butcher, *Pioneer History of Custer County*, 112.

6. Butcher, *Pioneer History of Custer County*, 208.

7. Butcher, *Pioneer History of Custer County*, 112.

8. Butcher, *Pioneer History of Custer County*, 131.

9. Solomon D. Butcher photograph, "Cowboy Dancing Lesson," *Prairie Settlement: Nebraska Photographs and Family Letters, 1862–1912* (American Memory, Library of Congress), http://memory.loc.gov/cgi-bin/query/D?psbib:4:./temp/~ammem_6eCX::.

10. Butcher, *Pioneer History of Custer County*, 9.

11. Butcher, *Pioneer History of Custer County*, 162.

12. Butcher, *Pioneer History of Custer County*, 317.

Years of Trial, Years of Change

1. Butcher, *Pioneer History of Custer County*, 75.

2. Olson, *History of Nebraska*, 249.

3. Welsch, *Sod Walls*, 16.

4. Olson, *History of Nebraska*, 167.

5. Welsch, *Treasury of Nebraska Pioneer Folklore*, 48–49.

6. Creigh, *Nebraska*, 126.

7. Olson, *History of Nebraska*, 225 and 226.

8. Solomon D. Butcher Papers, State Archives, Nebraska State Historical Society, Lincoln.

9. Luebke, *Nebraska*, 231.

10. Purcell, *Pioneer Stories of Custer County, Nebraska*, 9.

11. Butcher, *Pioneer History of Custer County*, 293 and 294.

12. Olson, *History of Nebraska*, 253.

13. Butcher, *Pioneer History of Custer County*, 154.

14. Butcher, *Pioneer History of Custer County*, 154.

Pioneer History of Custer County

1. Gifford and Shestak, "Solomon Butcher."

2. Butcher, *Pioneer History of Custer County*, preface.

3. *Custer County Chief*, March 1 and March 8, 1901, Solomon D. Butcher Papers, State Archives, Nebraska State Historical Society, Lincoln. See also Carter, *Solomon D. Butcher*, 6.

4. Butcher, *Pioneer History of Custer County*, dedication.

5. Butcher, *Pioneer History of Custer County*, 153–54.

6. Olson, *History of Nebraska*, 249.

7. Solomon Butcher to Addison Sheldon, n.d., Solomon D. Butcher Papers, State Archives, Nebraska State Historical Society, Lincoln.

8. Welsch, *Sod Walls*, xii.

9. Solomon Butcher to Addison Sheldon, September 29, 1915, Solomon D. Butcher Papers, State Archives, Nebraska State Historical Society, Lincoln.

Sweet Nebraska Land

1. Tom Wright, *Aynsley Herald*, September 11, 1952, Solomon D. Butcher Papers, State Archives, Nebraska State Historical Society, Lincoln.

2. Solomon Butcher to Addison Sheldon, April 24, 1926, Solomon D. Butcher Papers, State Archives, Nebraska State Historical Society, Lincoln.

3. David Vestal, "Nebraska," *U.S. Camera Annual*, 1971, Solomon D. Butcher Papers, State Archives, Nebraska State Historical Society, Lincoln.

4. Butcher, *Pioneer History of Custer County*, 153.

5. Mrs. Thelma Rosso Johnson to Harry E. Chrisman, October 29, 1964, photocopy at Solomon D. Butcher Papers, State Archives, Nebraska State Historical Society, Lincoln.

6. Solomon D. Butcher Papers, State Archives, Nebraska State Historical Society, Lincoln.

7. Haumont, "Pioneer Years in Custer County," 236.

8. Butcher, *Pioneer History of Custer County*, 151.

Bibliography

Barns, Cass G. *The Sod House*. Lincoln: University of Nebraska Press, 1970.

Butcher, Solomon D. *Pioneer History of Custer County, and Short Sketches of Early Days in Nebraska*. Broken Bow NE: S. D. Butcher and Ephraim S. Finch, 1901.

Carter, John E. *Solomon D. Butcher: Photographing the American Dream*. Lincoln: University of Nebraska Press, 1995.

Cather, Willa. *My Antonia*. Boston: Houghton Mifflin, 1954.

———. *O Pioneers!* Boston: Houghton Mifflin, 1959.

Chrisman, Harry E. "The Sod House Photographs of Solomon D. Butcher." *The West*, July 1968, 28–31, 60–61.

Creigh, Dorothy Weyer. *Nebraska: A Bicentennial History*. New York: W. W. Norton, 1977.

Daughters of the American Revolution, Nebraska, ed. *Collection of Nebraska Pioneer Reminiscences*. Cedar Rapids IA: Torch Press, 1916.

Dick, Everett. *The Sod-House Frontier, 1854–1890: A Social History of the Northern Plains from the Creation of Kansas and Nebraska to the Admission of the Dakotas*. Lincoln: University of Nebraska Press, 1979.

Gaston, W. L., and A. R. Humphrey. *History of Custer County, Nebraska*. Lincoln NE: Western Publishing and Engraving Company, 1919.

Gifford, J. Nebraska, and Melvin B. Shestak. "Solomon Butcher: A Photographer of the Great Plains Who Sought to Capture the Vanishing Pioneer." *American Photographer* 4, no. 1 (January 1980): 54–62.

Haumont, Jules. "Pioneer Years in Custer County." *Nebraska History Magazine* 18, no.4 (October–December 1932): 223–37.

Holt, Marilyn Irvin. *Children of the Western Plains: The Nineteenth-Century Experience*. Chicago: Ivan R. Dee, 2003.

Luebke, Frederick C. *Nebraska: An Illustrated History*. Lincoln: University of Nebraska Press, 1995.

Newhall, Beaumont. *The History of Photography: From 1839 to the Present*. New York: Museum of Modern Art, 1982.

Nicoll, Bruce. *Nebraska: A Pictorial History*. Lincoln: University of Nebraska Press, 1967.

Olson, James C. *History of Nebraska*. Lincoln: University of Nebraska Press, 1966.

Purcell, Emerson R. *Pioneer Stories of Custer County, Nebraska*. Broken Bow NE: Custer County Chief, 1936.

Rolvaag, O. E. *Giants in the Earth*. New York: Harper and Row, 1927.

Sandoz, Mari. *Love Song to the Plains*. Lincoln: University of Nebraska Press, 1961.

———. *Old Jules*. Lincoln: University of Nebraska Press, 1962.

Solomon D. Butcher Papers, State Archives, Nebraska State Historical Society, Lincoln.

Tunis, Edwin. *Frontier Living: An Illustrated Guide to Pioneer Life in America, Including Log Cabins, Furniture, Tools, Clothing, and More*. Cleveland: World Publishing, 1961.

Ward, Geoffrey C. *The West: An Illustrated History*. New York: Little,
 Brown and Company, 1996.
Welsch, Roger L. *Sod Walls: The Story of the Nebraska Sod House*.
 Broken Bow NE: Purcells, 1968.
——. *A Treasury of Nebraska Pioneer Folklore*. Lincoln: University of
 Nebraska Press, 1984.